Watercolor

The Easy Way

Step-by-Step Tutorials for 50 Beautiful Motifs
Including Plants, Flowers, Animals & More

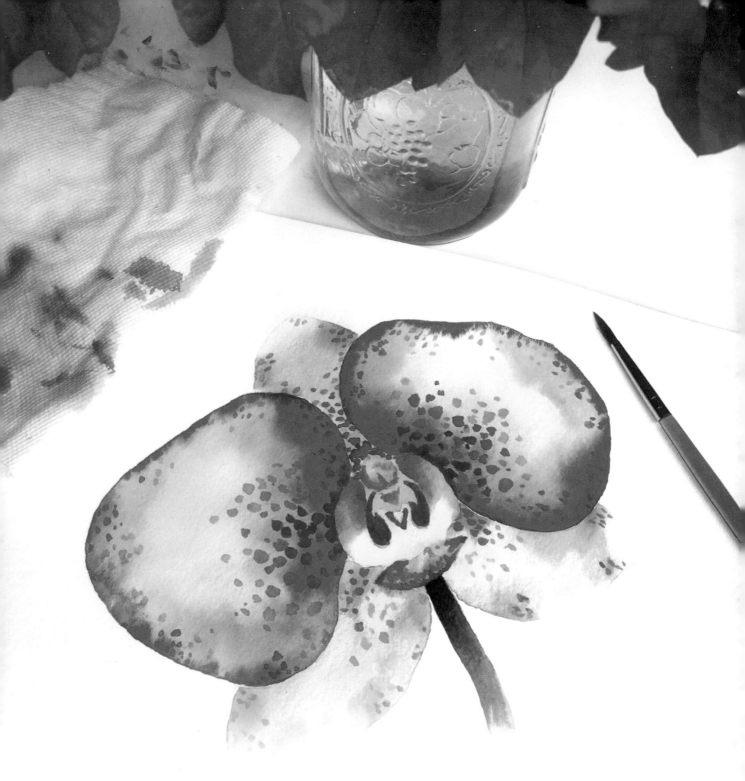

Library of Congress Control Number: 2019945772

Acquisition and Content Development — Peg Couch, Editors — Mary Sullivan Hutcheson, Katie Weeber, Design — Michael Douglas.

ISBN: 978-0-7643-5982-8

Printed in China

Copublished by Better Day Books and Schiffer Publishing, Ltd.

Schiffer Publishing, Ltd.
4880 Lower Valley Road | Atglen, PA 19310
Phone: (610) 593-1777; Fax: (610) 593-2002
E-mail: Info@schifferbooks.com | Web: www.schifferbooks.com

This title is available for promotional or commercial use, including special editions. Contact info@schifferbooks.com for more information.

Watercolor

The Easy Way

Step-by-Step Tutorials for 50 Beautiful Motifs
Including Plants, Flowers, Animals & More

SARA BERRENSON

BETTER DAY BOOKS

HAPPY · CREATIVE · CURATED

Contents

WATERCOLOR TUTORIALS 26

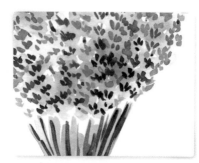

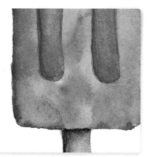

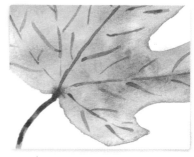

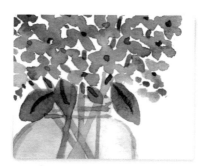

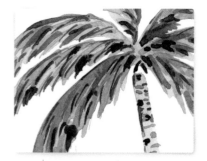

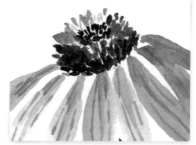

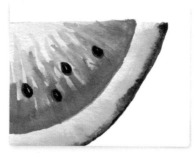

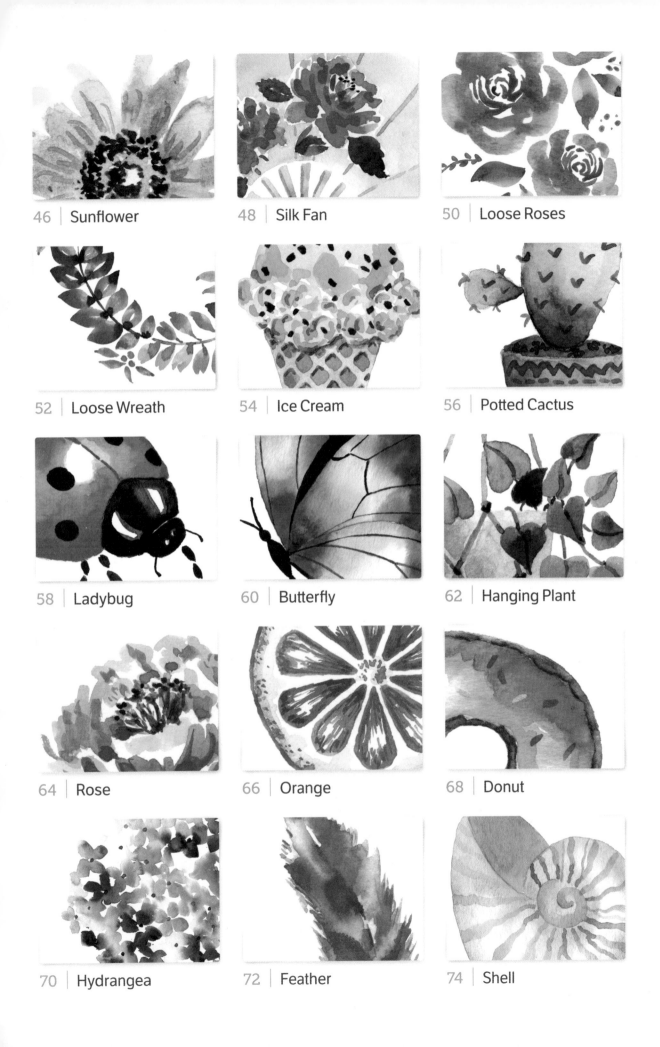

46 | Sunflower

48 | Silk Fan

50 | Loose Roses

52 | Loose Wreath

54 | Ice Cream

56 | Potted Cactus

58 | Ladybug

60 | Butterfly

62 | Hanging Plant

64 | Rose

66 | Orange

68 | Donut

70 | Hydrangea

72 | Feather

74 | Shell

HOUSE of FASHION

Welcome

Watercolor the Easy Way is a project book that helps you learn basic watercolor techniques and create beautiful paintings. This book will show you step by step how to create 50 paintings, including flowers, fruits, desserts, animals, and more. The tutorials in this book will encourage you to explore watercolor in a way that is approachable and fun. Watercolor is sometimes considered to be a daunting medium—but it doesn't have to be! We will learn fundamental techniques, color mixing, and how to create different brushstrokes for a variety of projects. It is my hope that the lessons here introduce you to the magic of watercolor, spark your creativity, and provide you with a place to explore and discover your inner artist.

About the Author: Sara Berrenson is a painter and illustrator based in Santa Monica, California. She is inspired by color combinations, textures, and patterns found in nature. She has collaborated with such brands as West Elm, Pottery Barn Kids, Trader Joe's, Mattel, and many others. On the weekends you can find her at the flower mart taking photos for her next watercolor, or at the flea market scouting out antique furniture and vintage fabric.

www.saraberrenson.com

 saraberrenson

Getting Started

SUPPLIES

Watercolor Paint

Watercolor paint comes in student grade and professional grade. Professional grade paints usually provide more intense color because they are highly pigmented. However, I use a variety of both grades and am always happy with the results!

Watercolor paint comes in tubes, pans, and bottles of liquid. I prefer pans because of their portability, but all options work well.

Brushes

For all of the projects in this book, I used round watercolor brushes in a variety of sizes. Brushes are numbered by size; the higher the number, the larger the brush. Larger brushes are good for broad areas of color, while smaller brushes add fine details. I would recommend using round brushes in sizes 2, 3, 4, 6, 8, and 10.

Paper

I would recommend using cold-press watercolor paper, 140 lb.

Mixing Palette

Many watercolor pan sets come with a built-in mixing palette, but it is always nice to have additional space to mix colors. I use a plastic palette that folds open and closed and measures about 10" x 10" when open. It's portable and doesn't take up too much space when put away.

Clean Water

I usually use a standard mason jar for this. Make sure to replace your water when it starts to get too dirty so it doesn't muddy up your colors!

Paper Towels

Keep these next to your water jar to dab off excess water and paint from your brush.

Tracing Paper and Graphite Paper

Each tutorial in this book has a sketch that you can trace and then transfer to your watercolor paper for painting.

Masking Fluid (Optional)

This brush-on liquid can be brushed onto paper to preserve the paper color or other previously painted areas. It repels both paint and water and peels away without marring the paper surface. We will use this for the Masked Moon tutorial on page 126.

COLORS

I have provided color swatches for each tutorial so you can match them as best you can; however, it's totally OK if they don't match exactly. We will go over the basics of color theory and color mixing so you can learn how to create endless colors on your own.

For this book, I recommend starting out with some basic colors:

- Warm and cool versions of yellow, red, blue, and green
- Violet
- Rose
- 2 earth tones
- Black

I have also included 5 of my other favorite colors that I use often.

White is not included, because we use water to lighten colors.

I have given my recommendations, but feel free to include your favorite colors. If your paint color names are not all the same as the ones listed here, don't worry! There are slight variations in each brand, and art stores will carry substitutions for each of the colors.

I would suggest painting a swatch of each of your watercolors, and labeling it with the color name. This way you will have a reference to refer back to while using this book. I have shown the painted swatches for the color palette I used.

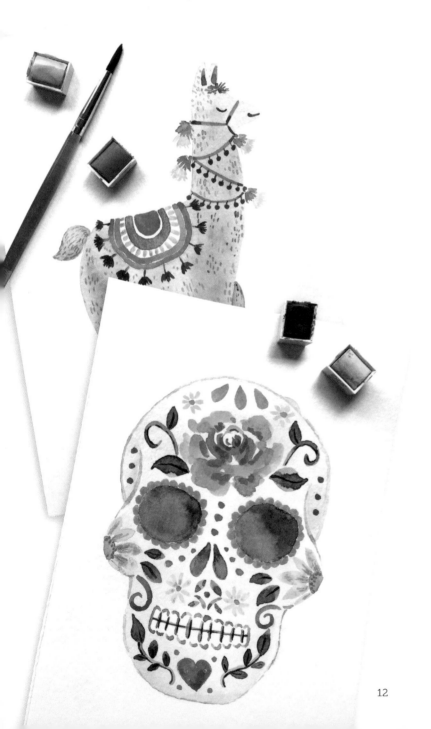

Basic Color Palette

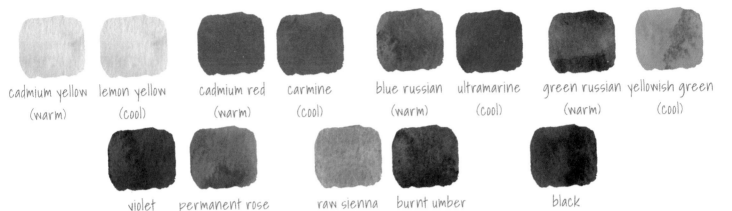

cadmium yellow (warm) lemon yellow (cool) cadmium red (warm) carmine (cool) blue russian (warm) ultramarine (cool) green russian (warm) yellowish green (cool)

violet permanent rose raw sienna burnt umber black

Additional Favorite Colors

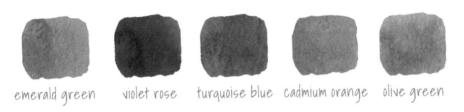

emerald green violet rose turquoise blue cadmium orange olive green

Creating a Paint Swatch

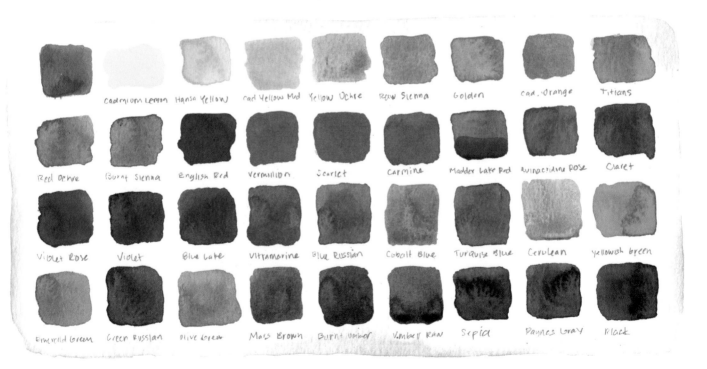

cadmium lemon Hansa Yellow cad Yellow Med Yellow Ochre Raw Sienna Golden cad. Orange Titians

Red Ochre Burnt Sienna English Red Vermillion Scarlet Carmine Madder Lake Red Quinacridine Rose Claret

Violet Rose Violet Blue Lake Ultramarine Blue Russian Cobalt Blue Turquoise Blue Cerulean yellowish Green

Emerald Green Green Russian Olive Green Mars Brown Burnt Umber Umber RAW Sepia Paynes Gray Black

Before starting a new painting session, it's a good idea to create a swatch card. Simply paint a small stroke of each color from your palette and let it dry. Then, you have a color reference to refer back to while painting. Above are the actual paint swatches that I used to create this book (complete with abbreviations, scribbles, and misspellings)!

MIXING COLORS

Even though your watercolor palette may include many colors, it is always helpful to learn some color theory basics so that you can mix your own unique colors. Let's start with understanding the color wheel.

Primary colors: Red, yellow, and blue. These colors are the root colors from which all other colors can be mixed.

Secondary colors: Orange, green, and violet. By mixing 2 primary colors together, you get a secondary color.

Tertiary colors: Orange yellow, red orange, red violet, violet blue, blue green and yellow green. By mixing 1 primary and 1 secondary color together, you get a tertiary color.

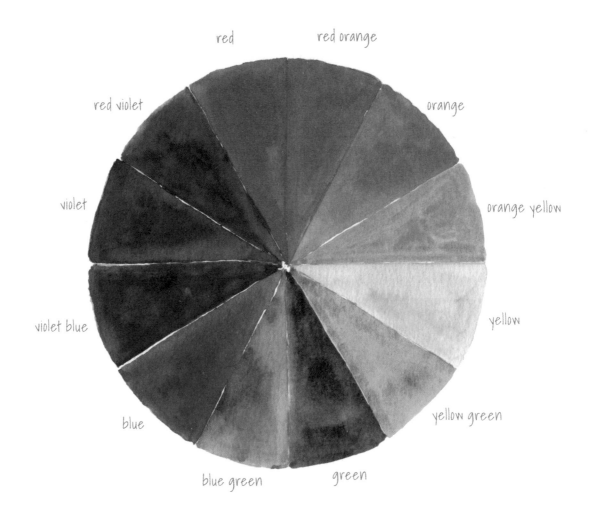

Primary Colors

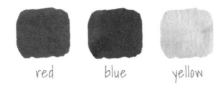

red blue yellow

How to Mix Secondary Colors

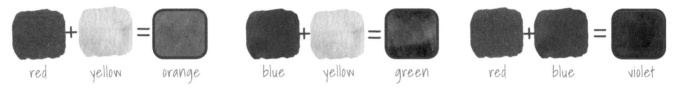

red + yellow = orange blue + yellow = green red + blue = violet

How to Mix Tertiary Colors

ultramarine + emerald green = blue green cadmium yellow + green russian = yellow green

violet + ultramarine = violet blue cadmium orange + cadmium yellow = orange yellow

carmine + violet = red violet cadmium red + cadmium orange = red orange

For this exercise I have listed out the exact paint colors that I use to achieve these combinations. Each color comes in a variety of shades, and each shade has either a warm or a cool undertone. In order to mix the most vibrant colors, a good rule of thumb is to mix cool colors with other cool colors, and warm colors with other warm colors. For example, a cool red and a cool blue will make a vibrant purple. However, if you mix a warm red with a cool blue, your purple will be a bit muddier and less vibrant.

How to Darken Colors

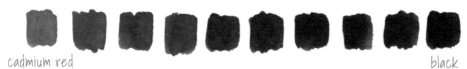

cadmium red black

If you would like to darken a color, add a small amount of black to the mixture. Above, I started with the pure color of cadmium red. I added a tiny bit of black to each swatch, until I end up with the darkest red.

I recommend you practice with your watercolors to create various color combinations. Have fun with it! The more you practice, the more you will get a feel for the colors and their broad possibilities.

Watercolor Basics

As the name implies, watercolor utilizes a combination of transparent color and water to work its magic. Depending on how much water and color are used, you can create a wide variety of effects.

I have experimented by painting a variety of circles. You can see that each time the edge of one circle touches another, the colors bleed into one another. When wet paint touches another area of wet paint, the two areas of paint will mix. I encourage you to play around with your paints to get a feel for watercolor and how it behaves. This circle exercise is a fun way to get started.

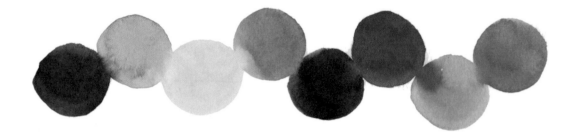

TECHNIQUES

Wet on Dry

Wet on Dry is simply applying paint to a dry surface, whether it be the dry paper or a layer of paint that has already dried.

Because your surface is dry, you need to make sure your brush has enough water so that your paint can flow smoothly. With too little water, you'll end up with a dry-brush effect. So how much water should you use? That depends on how light or dark you want your color to be!

More water will produce a more transparent (or see-through), lighter color. Less water will produce a more opaque, deeper, or darker color.

I have shown the color violet mixed with various amounts of water.

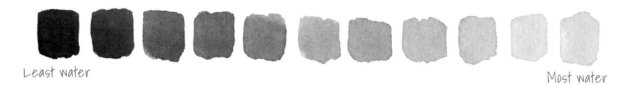

Least water

Most water

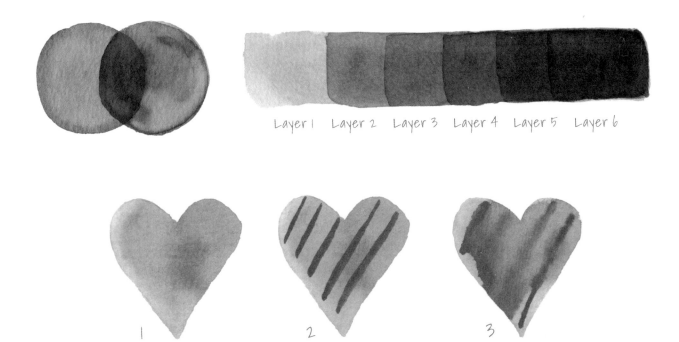

Layer 1 Layer 2 Layer 3 Layer 4 Layer 5 Layer 6

1 2 3

Layering

You can also use the Wet on Dry technique to build up layers, by adding paint on top of previously painted layers. Watercolor is translucent, so you can paint layers on top of one another to create darker shades of color.

The first example above shows two overlapping circles of paint. When you paint the second layer over the first, the area where they overlap becomes darker.

The second example shows the progression of layering color. First, I painted a long stripe with my color. Then I built up the color by painting one layer of paint at a time. You can see how the color darkens the more layers you apply.

Adding Details

You can also use the Wet on Dry technique to add details to your paintings.

1. The heart is painted with a layer of red.

2. Once it is completely dry, I go in and paint the stripe details on top of it. You can see how the second layer of paint is distinct and crisp.

3. If you do not let the paint dry before moving on to the next layer, you will end up with colors that bleed into one another.

Blending

Blending is the technique we use to create smooth color transitions when layering colors.

If you do not blend out the edges of your layers in the second and third coats, you may end up with hard edges. Sometimes we want this effect, but not if we are trying to create a smooth, round shape, as shown in the example below.

How to blend: Paint the first layer and let it dry completely. Lay the second coat of paint down. Next, dip your brush in water to remove all the excess paint. Using only water, touch your brush to the paint you just applied to soften the edges. Keep feathering out the paint with the water in whichever direction you are trying to blend.

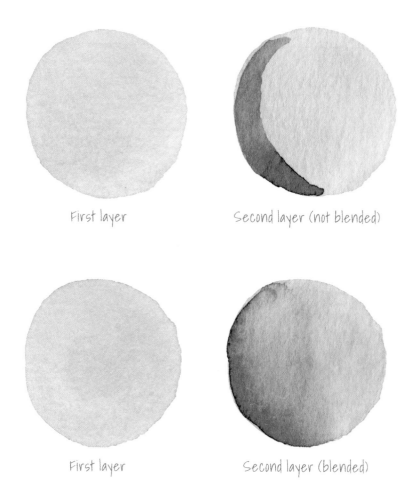

First layer

Second layer (not blended)

First layer

Second layer (blended)

Wet on Wet

Wet on Wet is when you add paint to an already wet surface. Wet on Wet is less controlled than Wet on Dry. The results are sometimes unpredictable, but the happy accidents and discoveries are part of the appeal! I used this technique often throughout this book.

Wet on Wet can be done in two ways:

1. Wetting the paper, then adding paint to it
2. Adding more paint to an area that already has wet paint

Wetting the Paper

Using a brush, wet the paper with a coat of water until it has a sheen to it. When you tilt your paper, it should look shiny and wet. If your paper really starts to buckle and warp, you may have used too much water. The more you practice, the more you will get the hang of it.

While the paper is still wet, get some paint on your brush and touch it to the wet area. See how the color bleeds into the water. Continue dropping in colors, and observe the effect. You can move the water and paint around with your brush to help control where the color flows.

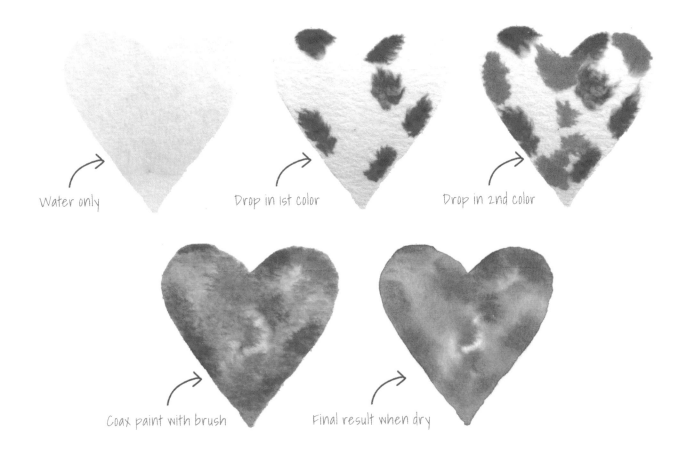

Water only

Drop in 1st color

Drop in 2nd color

Coax paint with brush

Final result when dry

Adding Wet Paint

Wet an area of paper with a coat of watercolor paint. While it is still wet, get some more paint on your brush and touch it to the wet area. You will see how it bleeds into the wet paint you first put down. Again, you can move the water and paint around with your brush to help coax it where to go.

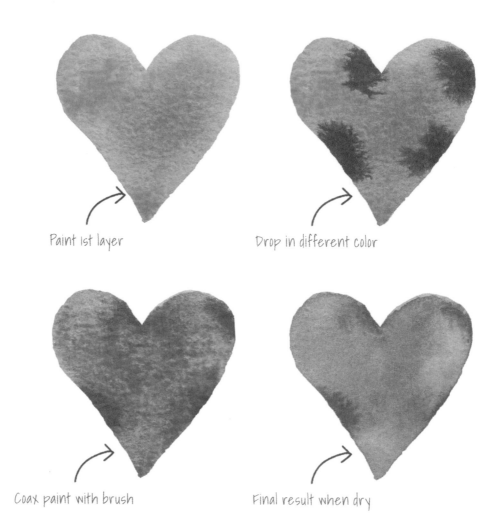

Paint 1st layer

Drop in different color

Coax paint with brush

Final result when dry

Lifting Color

Sometimes with watercolor, you can accidentally put on color that's too dark. We can't erase watercolor, but we can lift off some of the color while it's still wet by using a dry brush. To do this, first dip your brush in water and get all the paint off. Then dab on your paper towel to remove excess moisture. Then dip your dry brush into the wet color that is too dark. The dry bristles on your brush will start to absorb some of the pigment.

Washes

A watercolor wash is when you apply paint evenly to an area of paper. I have shown three kinds of washes.

A Flat Wash has the same amount of color spread evenly throughout. Load up your brush with lots of water and paint. Paint back and forth in a horizontal motion and make your way down the page. As the color starts to become lighter, pick up more paint with your brush and continue where you left off.

A Gradated Wash progresses from dark to light. Load up your brush with lots of water and paint. Paint back and forth in a horizontal motion and make your way down the page. You will notice that the color will become lighter as the pigment runs out. This creates the ombré effect of dark to light.

A Variegated Wash is when you transition one color into another one. Start with one color and make your way down the page. Next, pick up a different color on your brush and place it directly underneath your first color. You will see how the colors blend into one another.

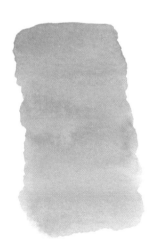

Flat wash

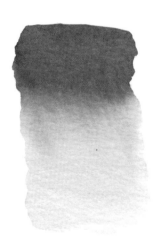

Gradated wash

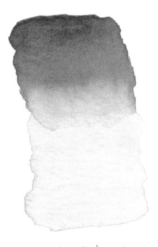

Variegated wash

Brushstrokes

Lines

Brushes are numbered by size; the higher the number, the larger the brush. As you can see below, you can get a lot of line variation with each brush, depending on how hard you press down. To create a thin line, use the tip of your brush and press very lightly. To create very thick lines, apply a lot of pressure as you paint.

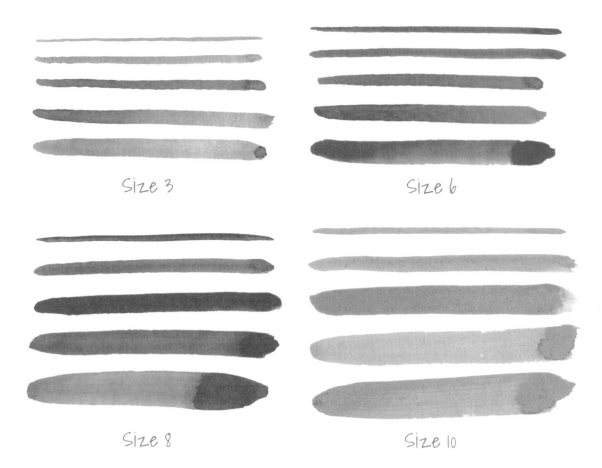

Size 3

Size 6

Size 8

Size 10

Strokes

You can achieve a lot of variety with your brush
by experimenting with different marks.

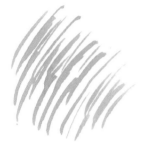

These strokes are good for
feathery lines, such as on
a bird's wing or tree with
wispy leaves.

These short little strokes
are good for creating fur.

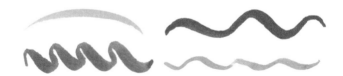

Play around with making curved lines and squiggles to get
a feel for all the possibilities.

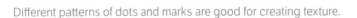

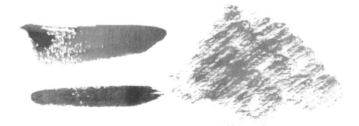

Different patterns of dots and marks are good for creating texture.

This technique is called dry brush. We barely use any water
on the brush but a good amount of paint. It creates a nice
effect for textures.

Loose Leaves

Loosely painted leaves are very fun to paint, and often they can be created using only one or two brushstrokes. By varying the pressure and angle of our brushstrokes, we can create many different shapes.

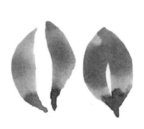

To create a leaf shape, touch the tip of your brush to the paper, press down, drag the brush along the paper and then slowly lift up until only your brush tip touches the paper again. This will create a leaf shape that is thin at both ends, but wider in the middle.

To create a leaf with a line of white showing through the center, repeat this brushstroke, but this time give it a slight curve. Repeat this on the other side. The top and bottom of each stroke should be touching. You should get a leaf that looks like this.

If we add a stem, we can make sprigs of leaves very easily.

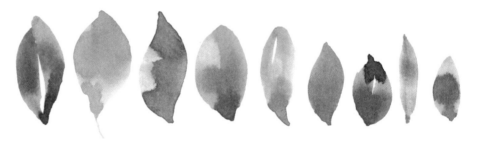

Try experimenting with your brushstrokes to create lots of different leaves!

Loose Petals

For this petal, touch the tip of your brush to the paper, press down, drag the brush along the paper and then slowly lift up until only your brush tip touches the paper again. This will create a petal shape that is thin at both ends, but fat in the middle.

 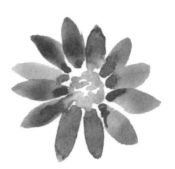

To create loose flowers, we can use the same technique as the leaves. With one brushstroke, we can create a petal. By varying the pressure and angle of the brushstroke, we can create different-shaped petals.

 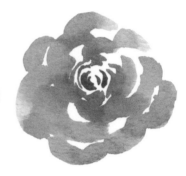

You can also create rose petals using this technique by slightly curving the brushstrokes as you go.

Start in the middle and work your way outward to create an entire rose.

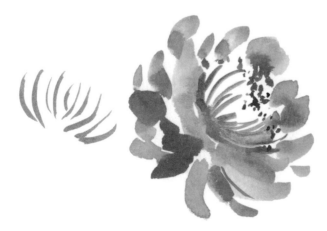 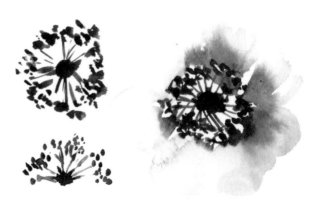

Very thin, curved strokes make good centers for many flowers.

A combination of thin strokes and dots makes a nice center for various flowers, especially poppies.

Watercolor
TUTORIALS

Now that we have covered the basics,
it's time to start painting!

In this section you will find 50 watercolor tutorials.
You will learn how to paint beautiful florals, animals,
and other stylish motifs. Each tutorial includes
a hand-drawn pattern to guide your painting,
brush recommendations, a suggested watercolor
palette, and illustrated steps to demonstrate
the painting process. Once your paintings
are complete you can frame and display
them or make beautiful cards and gifts.
The ideas are endless.

Let's get started!

TIP

Always store your brushes brush side up to keep the bristles fresh longer.

BRUSHES

• Medium brush (4, 6)

• Small brush for details (2, 3)

COLOR PALETTE

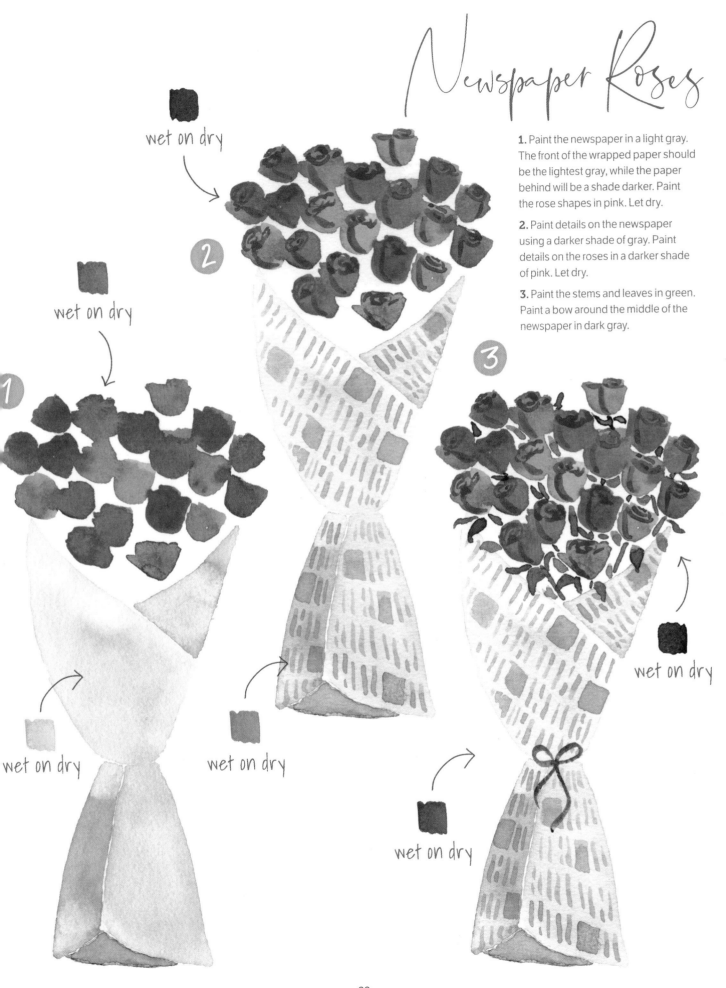

Newspaper Roses

1. Paint the newspaper in a light gray. The front of the wrapped paper should be the lightest gray, while the paper behind will be a shade darker. Paint the rose shapes in pink. Let dry.

2. Paint details on the newspaper using a darker shade of gray. Paint details on the roses in a darker shade of pink. Let dry.

3. Paint the stems and leaves in green. Paint a bow around the middle of the newspaper in dark gray.

wet on dry

wet on dry

wet on dry

wet on dry

wet on dry

wet on dry

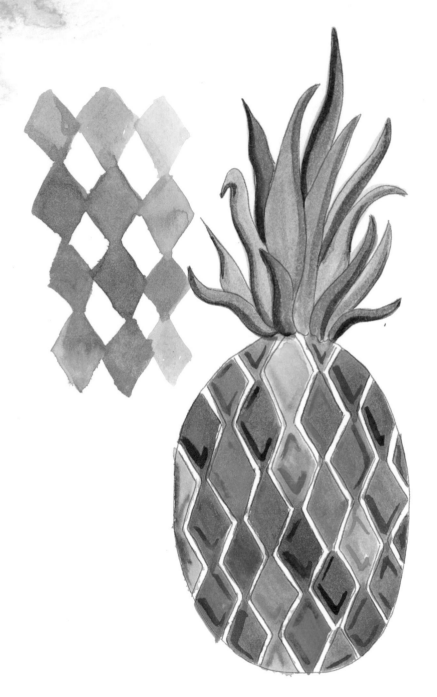

TIP
Happy color accidents
can happen when colors
mix on the palette.

BRUSHES

- Medium/large brush
 for pineapple (6, 8)
- Small/medium brush
 for details (3, 4)

COLOR PALETTE

Pineapple

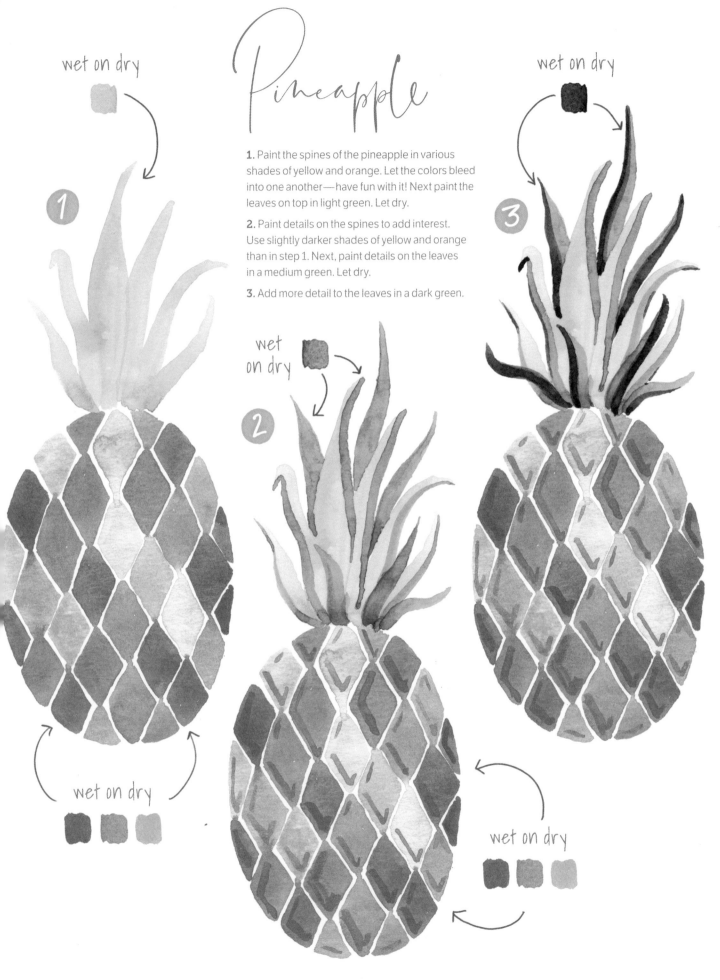

wet on dry

1. Paint the spines of the pineapple in various shades of yellow and orange. Let the colors bleed into one another—have fun with it! Next paint the leaves on top in light green. Let dry.

2. Paint details on the spines to add interest. Use slightly darker shades of yellow and orange than in step 1. Next, paint details on the leaves in a medium green. Let dry.

3. Add more detail to the leaves in a dark green.

1

wet on dry

wet on dry

2

wet on dry

3

wet on dry

wet on dry

TIP

Keep a steady hand when painting lavender sprigs so they are long and narrow.

BRUSHES

- Large brush for step 1 (10)
- Medium brush for step 2 (6)

COLOR PALETTE

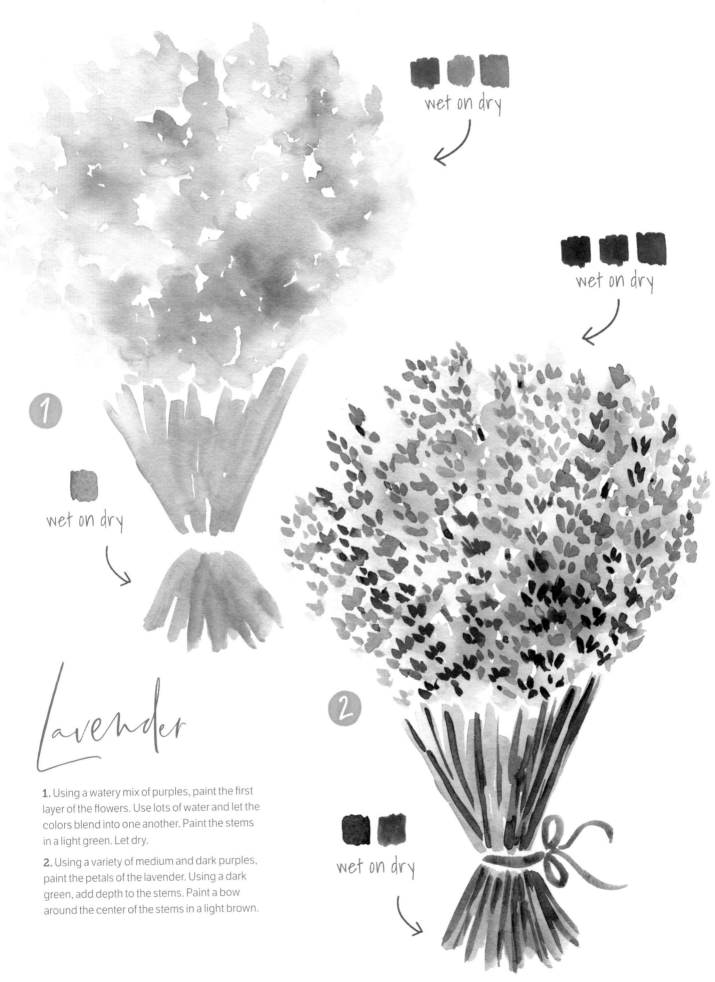

wet on dry

wet on dry

1

wet on dry

\mathcal{L}avender

1. Using a watery mix of purples, paint the first layer of the flowers. Use lots of water and let the colors blend into one another. Paint the stems in a light green. Let dry.

2. Using a variety of medium and dark purples, paint the petals of the lavender. Using a dark green, add depth to the stems. Paint a bow around the center of the stems in a light brown.

2

wet on dry

TIP
Paint outdoors. It's nice to
get some fresh air.

BRUSHES

- Large brush for popsicle
 and stick (8, 10)
- Small/medium brush
 for details (3, 4)

COLOR PALETTE

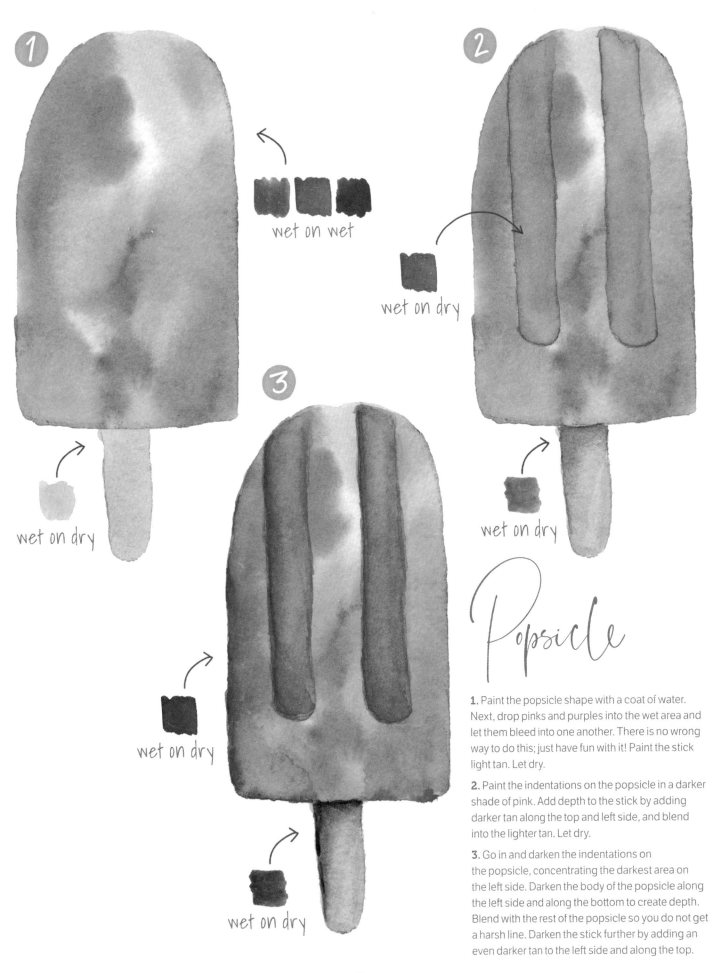

1 wet on wet

2 wet on dry

wet on dry

3 wet on dry

wet on dry

wet on dry

Popsicle

1. Paint the popsicle shape with a coat of water. Next, drop pinks and purples into the wet area and let them bleed into one another. There is no wrong way to do this; just have fun with it! Paint the stick light tan. Let dry.

2. Paint the indentations on the popsicle in a darker shade of pink. Add depth to the stick by adding darker tan along the top and left side, and blend into the lighter tan. Let dry.

3. Go in and darken the indentations on the popsicle, concentrating the darkest area on the left side. Darken the body of the popsicle along the left side and along the bottom to create depth. Blend with the rest of the popsicle so you do not get a harsh line. Darken the stick further by adding an even darker tan to the left side and along the top.

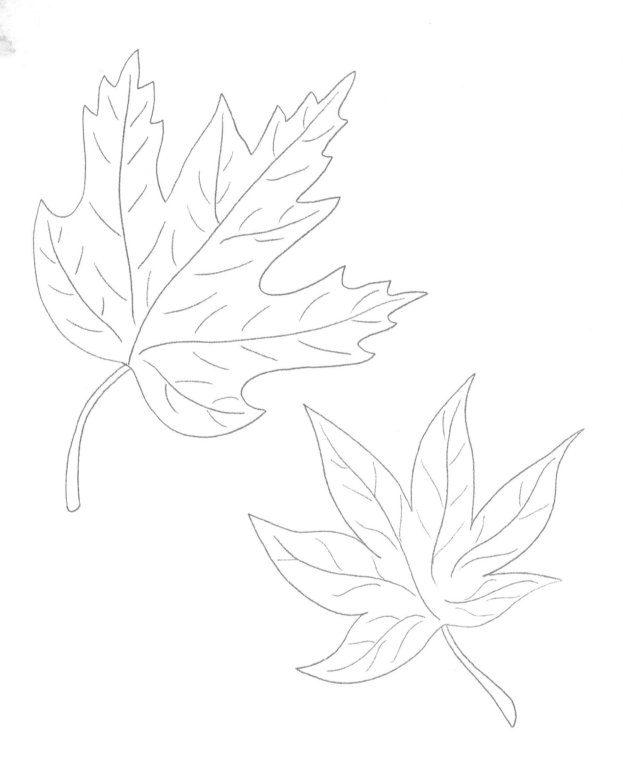

BRUSHES

- Large brush for leaves (8, 10)
- Small brush for details (2, 3)

COLOR PALETTE

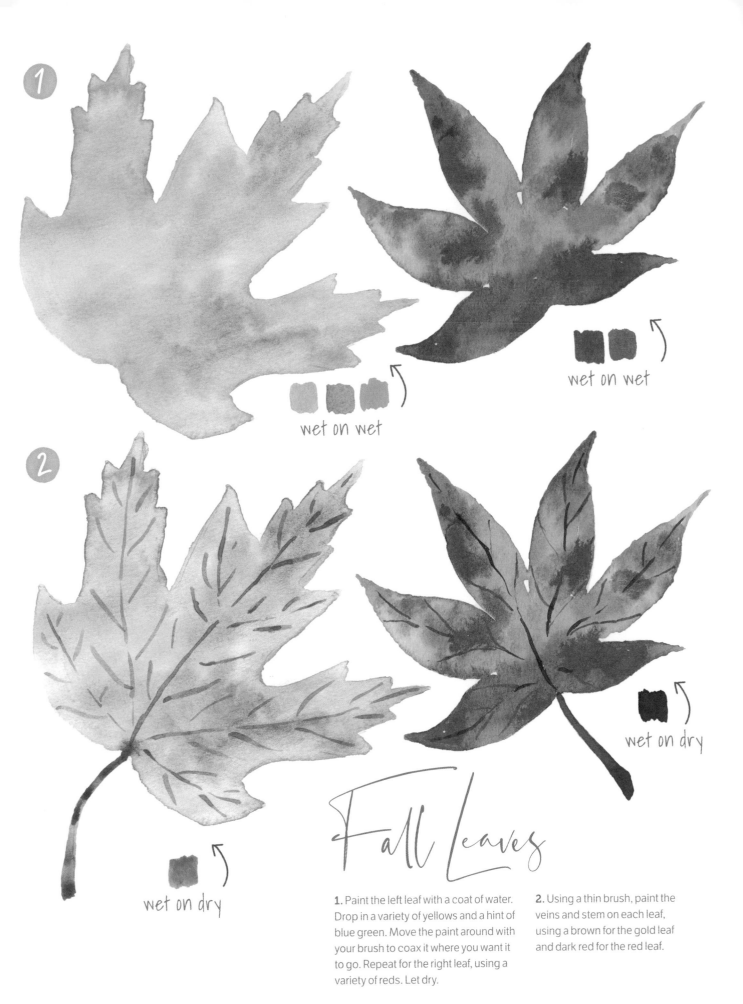

1 wet on wet

1 wet on wet

2 wet on dry

wet on dry

Fall Leaves

1. Paint the left leaf with a coat of water. Drop in a variety of yellows and a hint of blue green. Move the paint around with your brush to coax it where you want it to go. Repeat for the right leaf, using a variety of reds. Let dry.

2. Using a thin brush, paint the veins and stem on each leaf, using a brown for the gold leaf and dark red for the red leaf.

TIP

When you are feeling stuck, loosen up and paint upside down, paint with your opposite hand, or paint with your eyes closed!

BRUSHES

• Medium brush (4, 6)
• Small brush for details (2, 3)

COLOR PALETTE

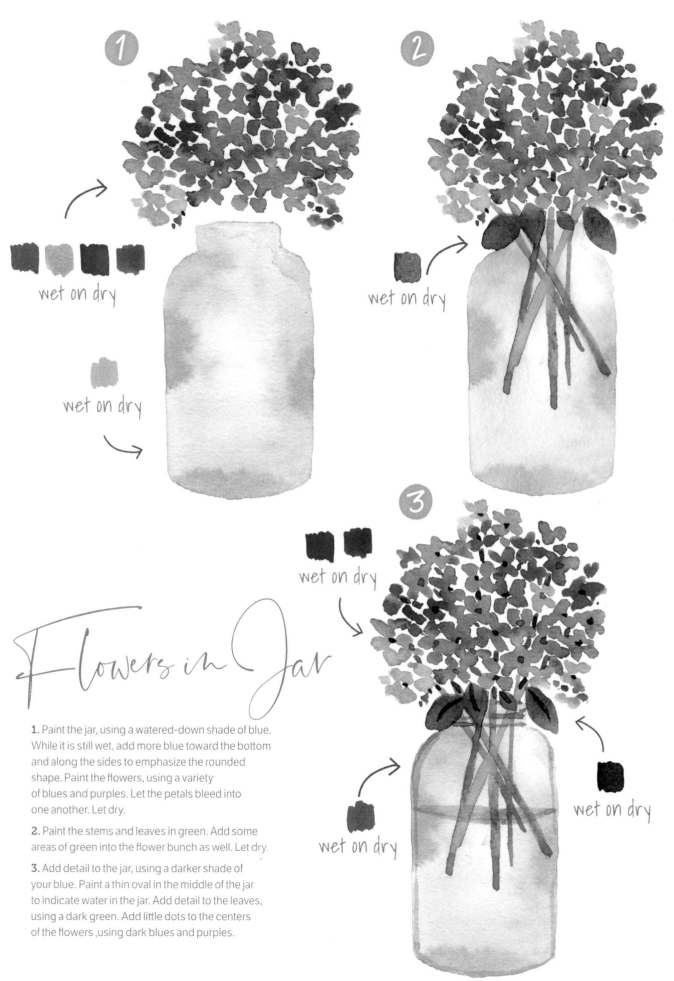

wet on dry

wet on dry

wet on dry

wet on dry

wet on dry

wet on dry

Flowers in Jar

1. Paint the jar, using a watered-down shade of blue. While it is still wet, add more blue toward the bottom and along the sides to emphasize the rounded shape. Paint the flowers, using a variety of blues and purples. Let the petals bleed into one another. Let dry.

2. Paint the stems and leaves in green. Add some areas of green into the flower bunch as well. Let dry.

3. Add detail to the jar, using a darker shade of your blue. Paint a thin oval in the middle of the jar to indicate water in the jar. Add detail to the leaves, using a dark green. Add little dots to the centers of the flowers ,using dark blues and purples.

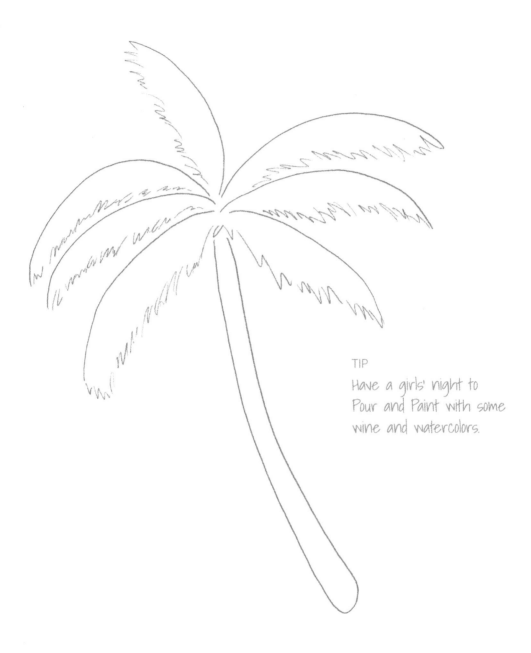

TIP
Have a girls' night to
Pour and Paint with some
wine and watercolors.

BRUSHES

- Medium/large brush for tree and leaves (6, 8)
- Small/medium brush for details (3, 4)

COLOR PALETTE

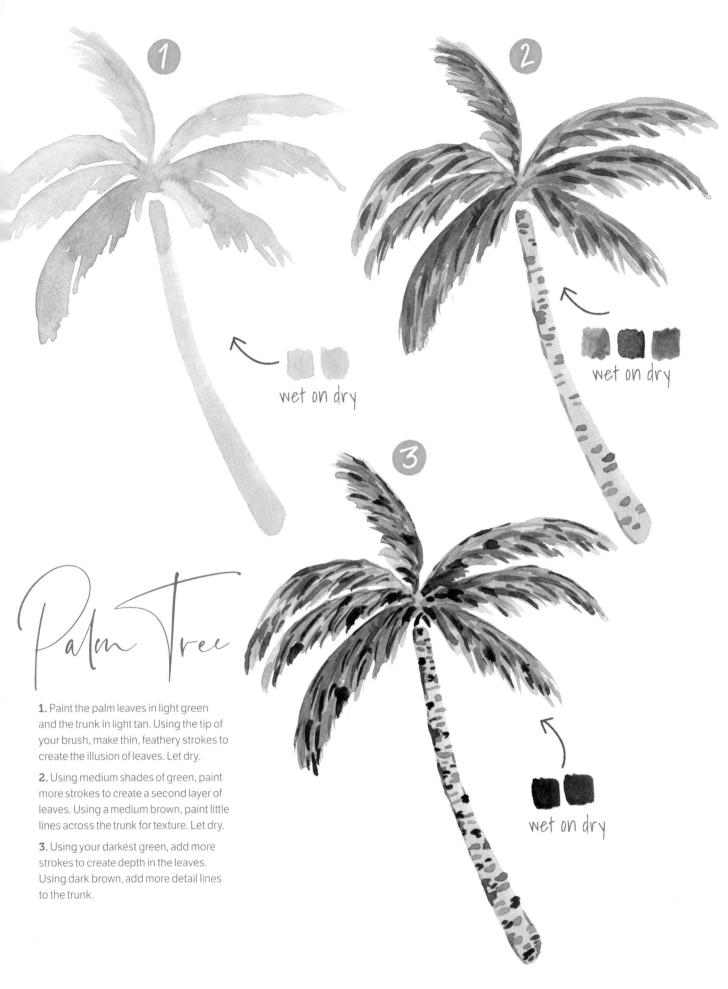

wet on dry

wet on dry

wet on dry

Palm Tree

1. Paint the palm leaves in light green and the trunk in light tan. Using the tip of your brush, make thin, feathery strokes to create the illusion of leaves. Let dry.

2. Using medium shades of green, paint more strokes to create a second layer of leaves. Using a medium brown, paint little lines across the trunk for texture. Let dry.

3. Using your darkest green, add more strokes to create depth in the leaves. Using dark brown, add more detail lines to the trunk.

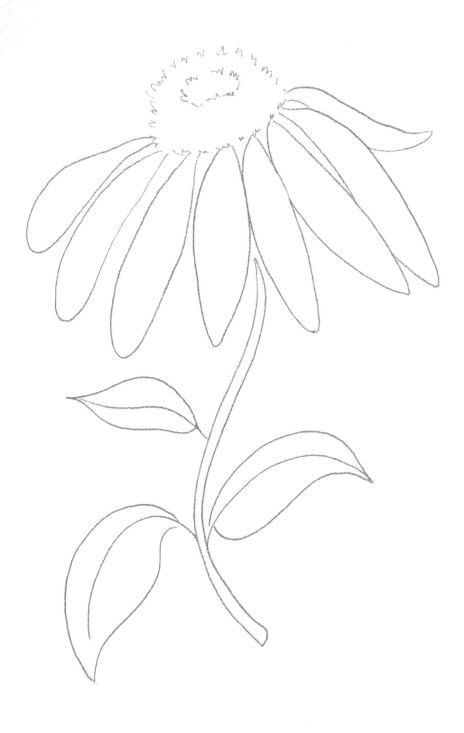

BRUSHES

- Large brush for center, leaves, and petals (8, 10)
- Small brush for details (2, 3)

COLOR PALETTE

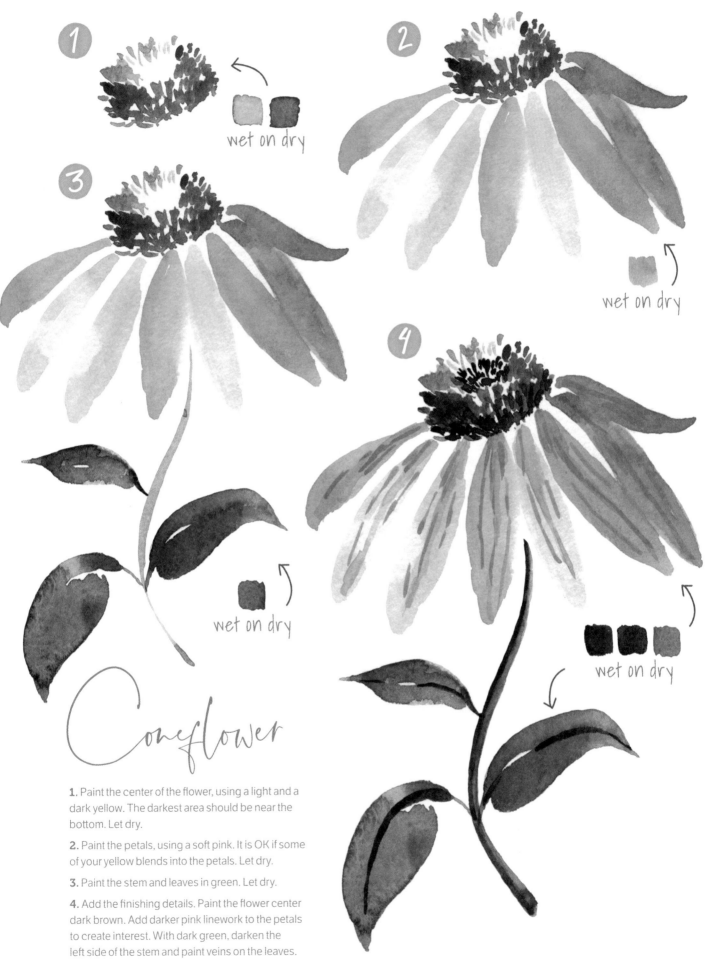

1 wet on dry

2 wet on dry

3 wet on dry

4 wet on dry

Coneflower

1. Paint the center of the flower, using a light and a dark yellow. The darkest area should be near the bottom. Let dry.

2. Paint the petals, using a soft pink. It is OK if some of your yellow blends into the petals. Let dry.

3. Paint the stem and leaves in green. Let dry.

4. Add the finishing details. Paint the flower center dark brown. Add darker pink linework to the petals to create interest. With dark green, darken the left side of the stem and paint veins on the leaves.

FUN TECHNIQUE—SPRAY AND PAINT:
Take a spray bottle with clean water and spray your paper. Load your brush with paint and dab the tip of the brush into the wet areas. The pigment will spread around and create some interesting organic textures.

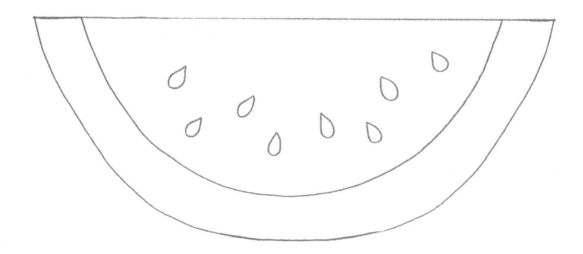

BRUSHES

• Medium/large brush for watermelon (6, 8)
• Medium brush for seeds (4, 6)

COLOR PALETTE

Watermelon

1. Paint the entire watermelon pulp area with a coat of water. While it's still wet, drop in red along the edges so it bleeds into the wash. Let dry.

2. Add details to create a texture on the watermelon. Use the same red color but dilute it with water so that it is a lighter pink. Let dry.

3. Use a light green to create the rind of the watermelon. Paint the outer edge of the rind in the green color, then use water to blend the color inward.

4. While the light green is still slightly wet, go in with a medium green along the edges of the rind. Because the paper is still wet, the medium green will blend into the lighter green. Last, add a thin outline of dark green to the outer edge. Let dry.

5. Paint the seeds black. Leave a little area in the center transparent to create the illusion of a highlight. Once dry, go in and add a shadow to the left side of the seed with red.

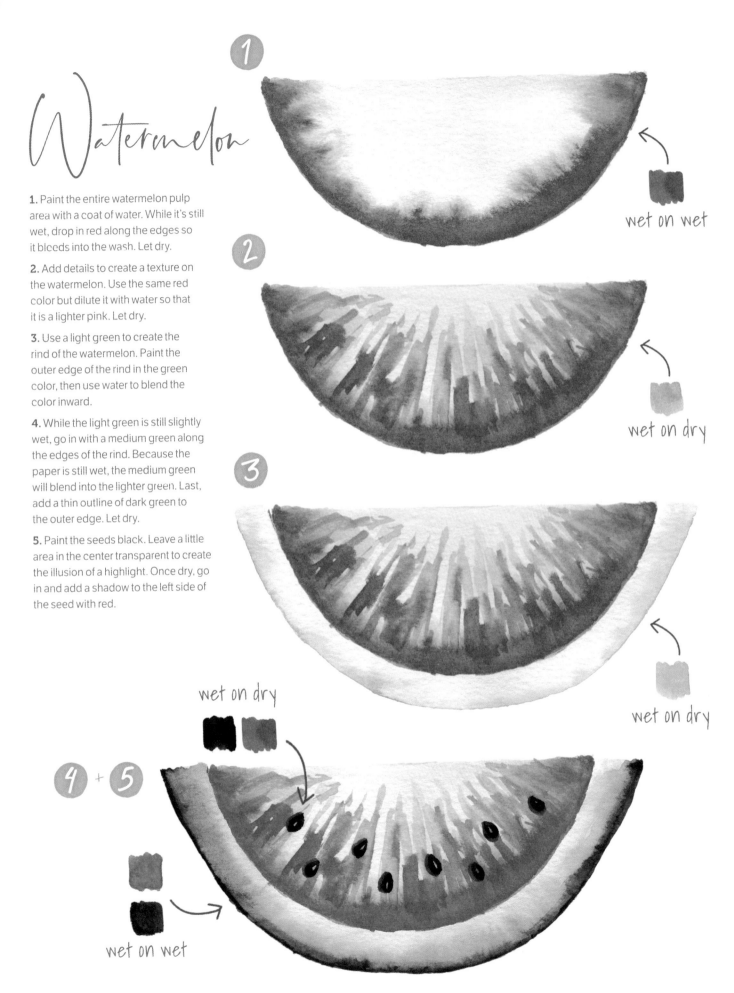

wet on wet

wet on dry

wet on dry

wet on dry

wet on wet

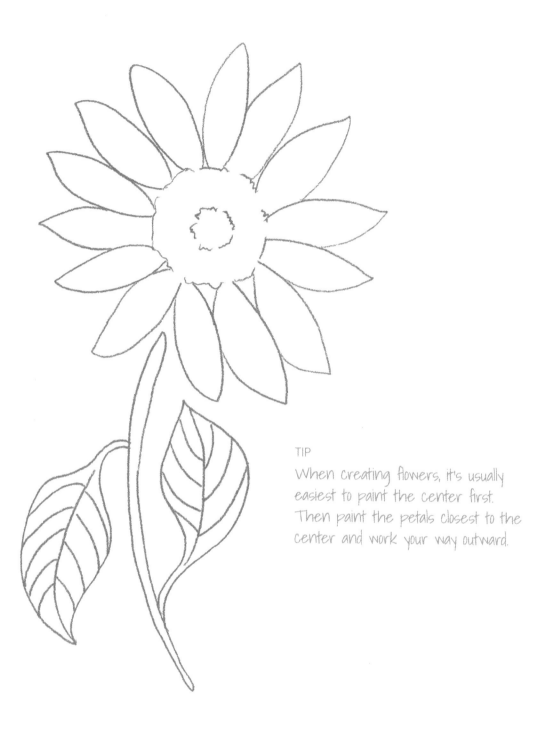

TIP

When creating flowers, it's usually easiest to paint the center first. Then paint the petals closest to the center and work your way outward.

BRUSHES

- Large brush for center and petals (8)
- Medium brush for stem, leaves, and details (4, 6)

COLOR PALETTE

Sunflower

1. Paint a group of yellow and dark yellow dots as the center of the sunflower.

2. While it's still wet, paint the yellow and dark-yellow petals, radiating out from the center. Let dry.

3. Add dark-brown dots to define the center further. Paint the green stem and leaves, leaving a white highlight in each leaf. Let dry.

4. Add small brushstrokes to add detail to the petals. Paint veins on the leaves in a dark green.

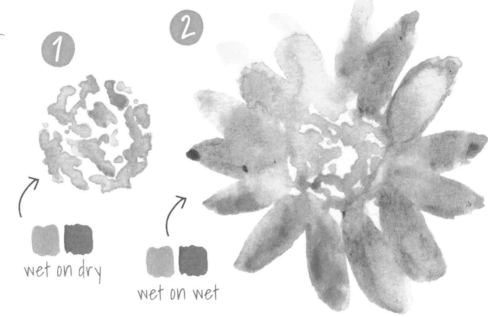

wet on dry

wet on wet

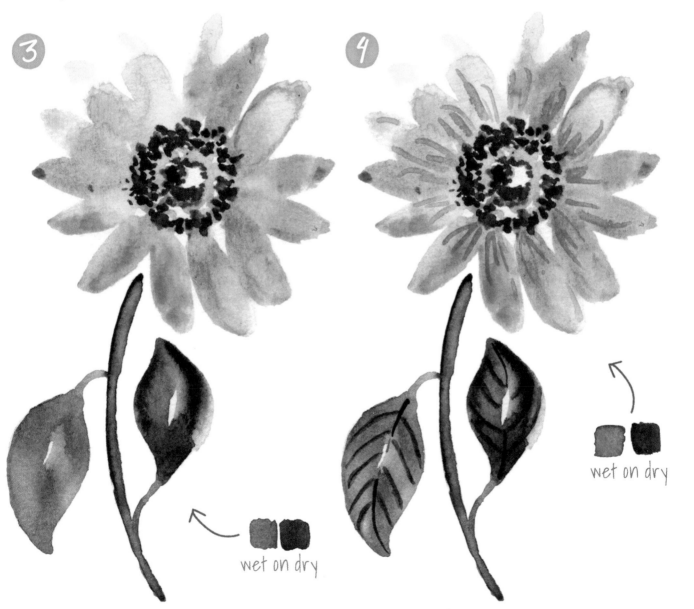

wet on dry

wet on dry

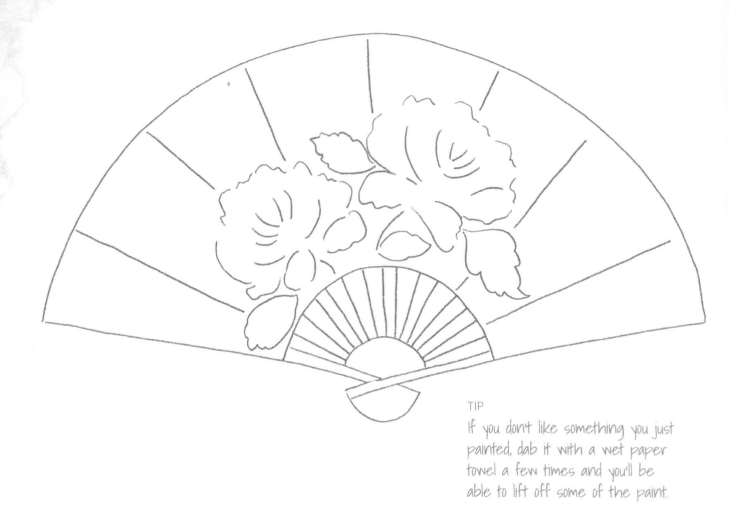

TIP

If you don't like something you just painted, dab it with a wet paper towel a few times and you'll be able to lift off some of the paint.

BRUSHES

- Medium brush for flowers (6)
- Large brush for fan (8)
- Medium brush for fan details (4, 6)

COLOR PALETTE

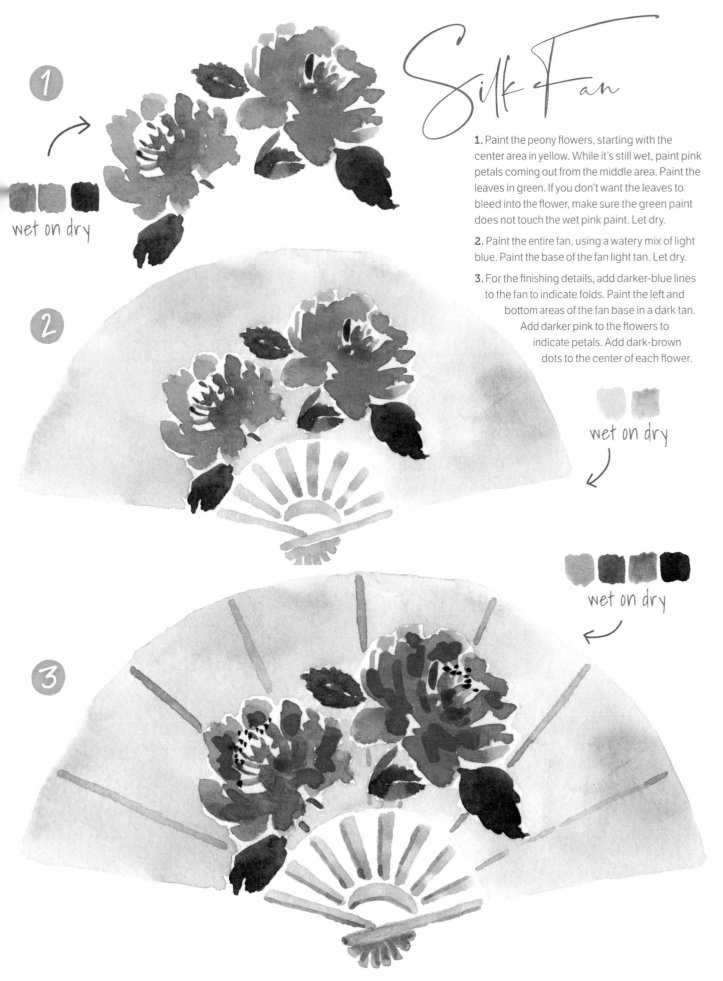

1

wet on dry

Silk Fan

1. Paint the peony flowers, starting with the center area in yellow. While it's still wet, paint pink petals coming out from the middle area. Paint the leaves in green. If you don't want the leaves to bleed into the flower, make sure the green paint does not touch the wet pink paint. Let dry.

2. Paint the entire fan, using a watery mix of light blue. Paint the base of the fan light tan. Let dry.

3. For the finishing details, add darker-blue lines to the fan to indicate folds. Paint the left and bottom areas of the fan base in a dark tan. Add darker pink to the flowers to indicate petals. Add dark-brown dots to the center of each flower.

2

wet on dry

wet on dry

3

49

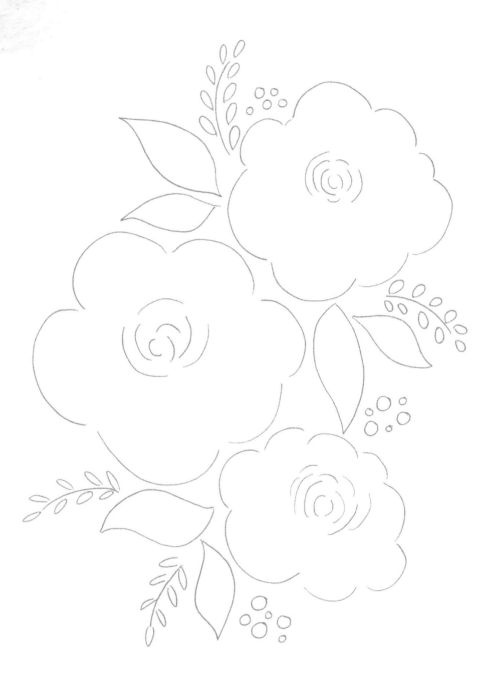

BRUSHES

- Large brush (8, 10)
- Use the tip of the brush to create the thinner lines and press down harder for the thicker areas.

COLOR PALETTE

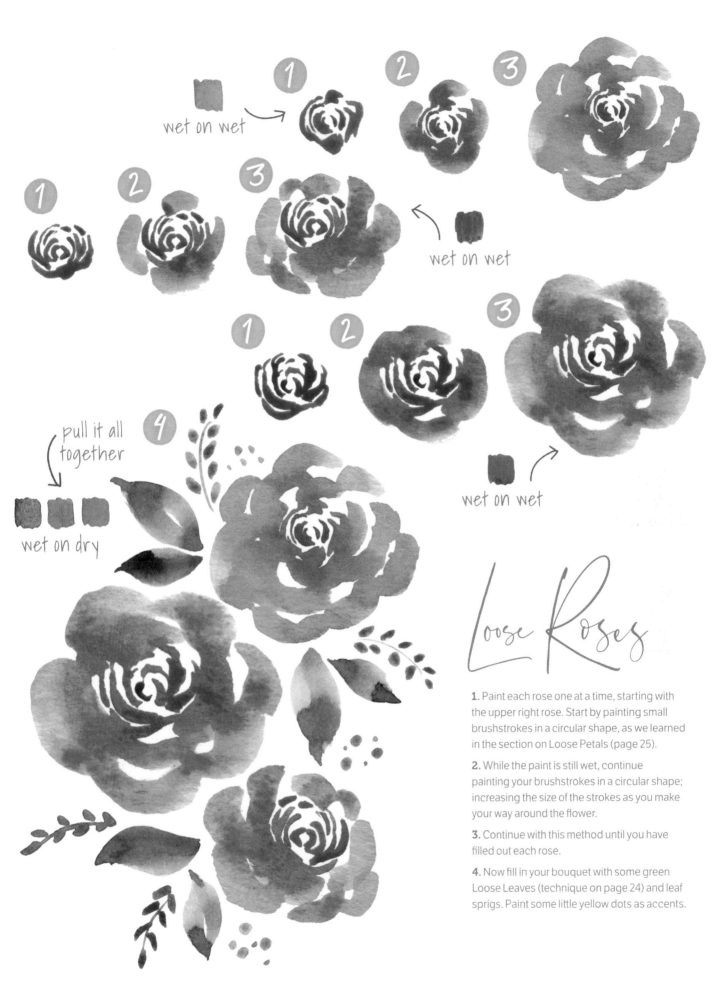

wet on wet

1

2

3

1

2

3

wet on wet

1

2

3

wet on wet

pull it all together

4

wet on dry

Loose Roses

1. Paint each rose one at a time, starting with the upper right rose. Start by painting small brushstrokes in a circular shape, as we learned in the section on Loose Petals (page 25).

2. While the paint is still wet, continue painting your brushstrokes in a circular shape; increasing the size of the strokes as you make your way around the flower.

3. Continue with this method until you have filled out each rose.

4. Now fill in your bouquet with some green Loose Leaves (technique on page 24) and leaf sprigs. Paint some little yellow dots as accents.

BRUSHES

- Large brush (8, 10)
- Use the tip of the brush to create the thinner lines and press down harder for the thicker areas.

COLOR PALETTE

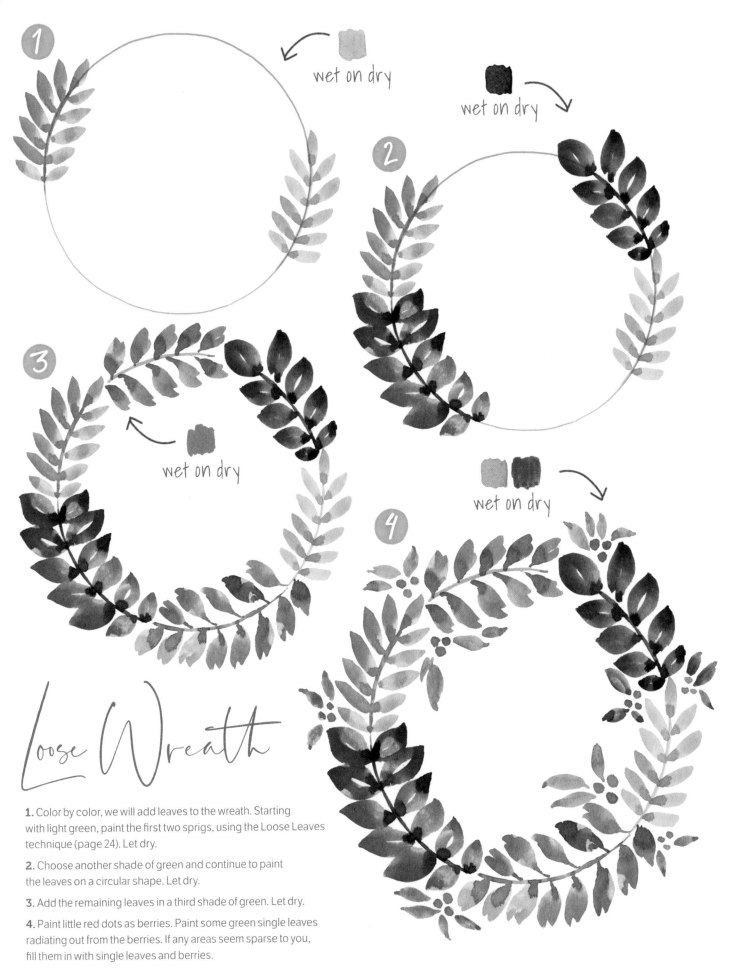

wet on dry

wet on dry

wet on dry

wet on dry

Loose Wreath

1. Color by color, we will add leaves to the wreath. Starting with light green, paint the first two sprigs, using the Loose Leaves technique (page 24). Let dry.

2. Choose another shade of green and continue to paint the leaves on a circular shape. Let dry.

3. Add the remaining leaves in a third shade of green. Let dry.

4. Paint little red dots as berries. Paint some green single leaves radiating out from the berries. If any areas seem sparse to you, fill them in with single leaves and berries.

TIP

Not every piece will be a masterpiece, and that's OK! Don't let it discourage you. Watercolor is all about practice and experimentation.

BRUSHES

- Large brush for steps 1 and 2 (8, 10)
- Small brush for details (3)

COLOR PALETTE

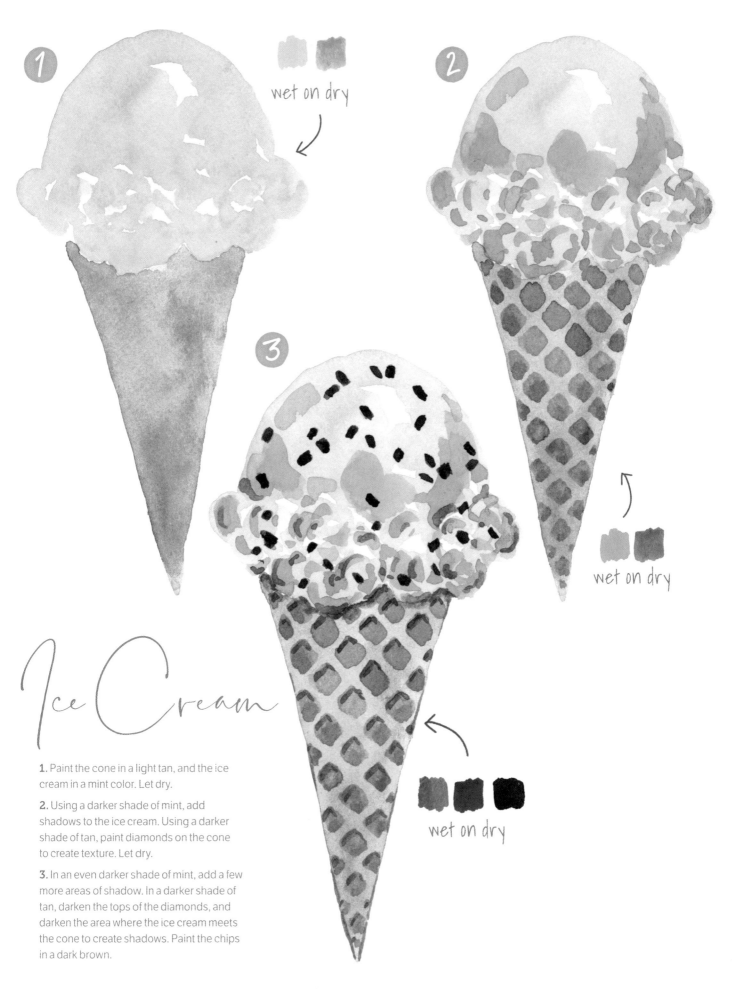

wet on dry

wet on dry

wet on dry

Ice Cream

1. Paint the cone in a light tan, and the ice cream in a mint color. Let dry.

2. Using a darker shade of mint, add shadows to the ice cream. Using a darker shade of tan, paint diamonds on the cone to create texture. Let dry.

3. In an even darker shade of mint, add a few more areas of shadow. In a darker shade of tan, darken the tops of the diamonds, and darken the area where the ice cream meets the cone to create shadows. Paint the chips in a dark brown.

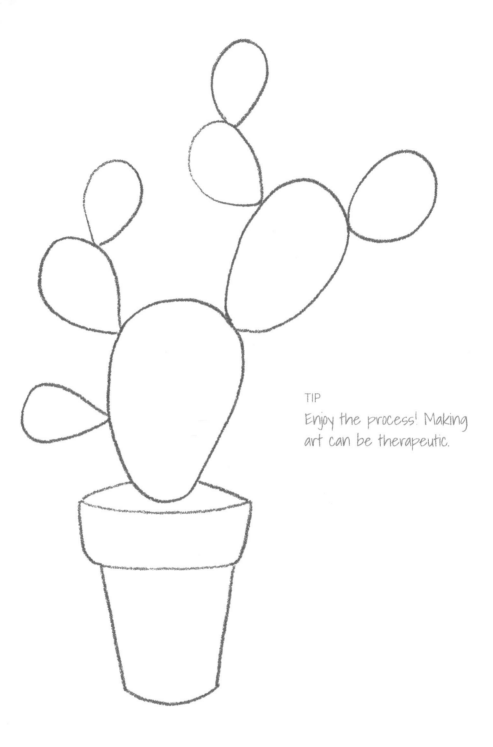

TIP

Enjoy the process! Making art can be therapeutic.

BRUSHES

- Medium brush (4, 6)
- Small brush for details (2, 3)

COLOR PALETTE

Potted Cactus

1. Paint the entire cactus with a coat of water. While it's still wet, drop dark green into the bottom halves of the cactus sections and light green into the upper halves. Make sure your paint is wet enough to let the colors blend into one another. Once the cactus is dry, paint one coat of burnt sienna on the pot. Once that dries, paint the dirt a dark brown. Let dry.

2. Create depth by layering. Add more burnt sienna to the left side of the pot and soften the edges with water so it blends with the rest of the pot. Do the same for the cactus, by adding dark green to the base of each segment. Use water to soften the edges and blend upward into the lighter areas. Let dry.

3. Use a small brush to add details. Add spikes to the cactus and decorative elements to the pot.

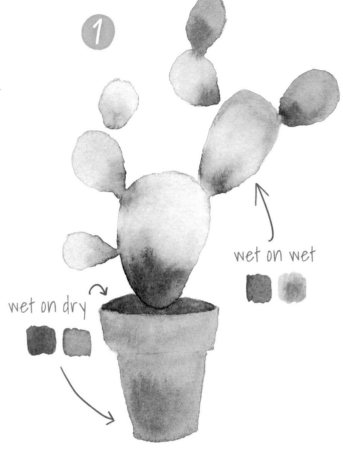

wet on wet

wet on dry

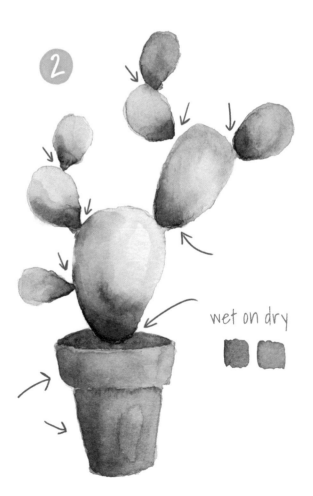

wet on dry

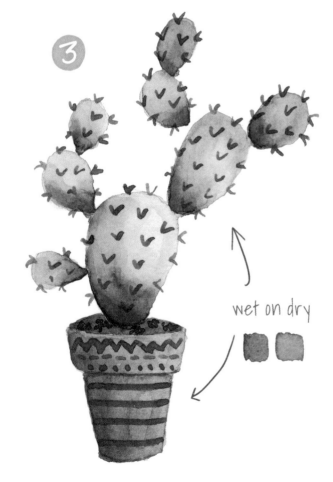

wet on dry

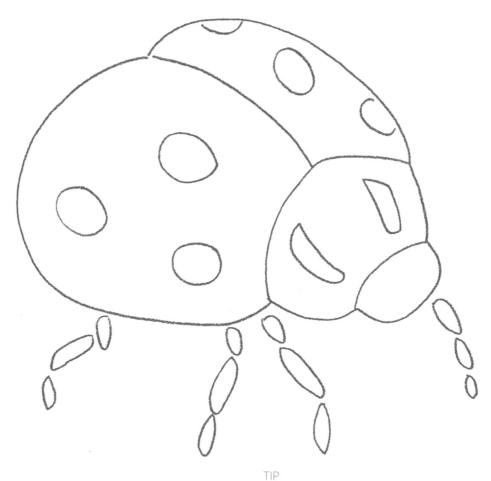

TIP

Look closely—go outside and observe
the many different kinds of leaves
and flowers you see. You may find
a ladybug on a leaf!

BRUSHES

- Medium brush (4, 6)

COLOR PALETTE

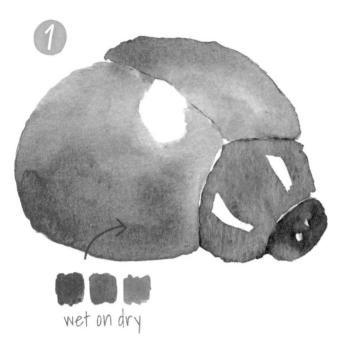

wet on dry

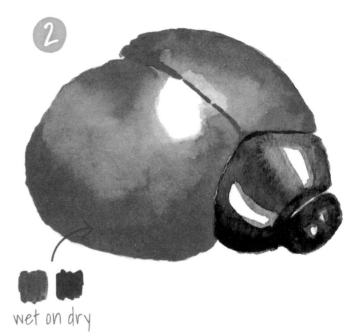

wet on dry

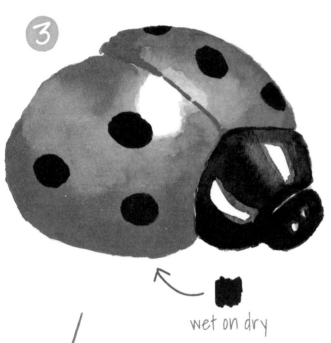

wet on dry

Ladybug

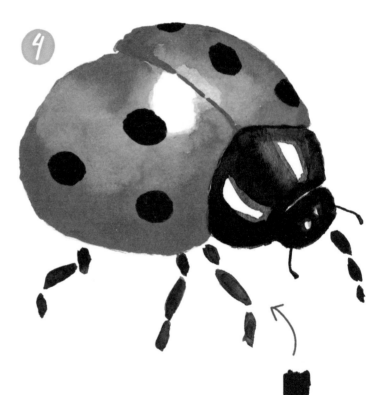

wet on dry

1. Paint the body of the ladybug light red with a hint of orange. Leave a spot of white for the highlight. Paint the head gray and leave spots for highlights here as well. Let dry.

2. Darken the red near the bottom, along the sides, and down the middle of the body to create depth. Using water, blend the darker-red areas into the lighter areas. Using a dark gray, do the same for the head. Let dry.

3. Using black, paint spots on the ladybug. Then darken the head one more time. Let dry.

4. Using black, paint the legs and antennae.

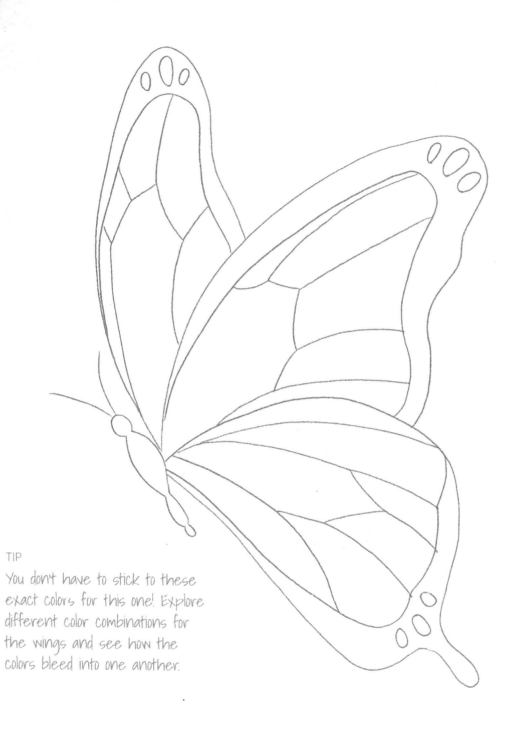

TIP

You don't have to stick to these exact colors for this one! Explore different color combinations for the wings and see how the colors bleed into one another.

BRUSHES

- Large brush for body (8, 10)
- Small brush for veins (2, 3)

COLOR PALETTE

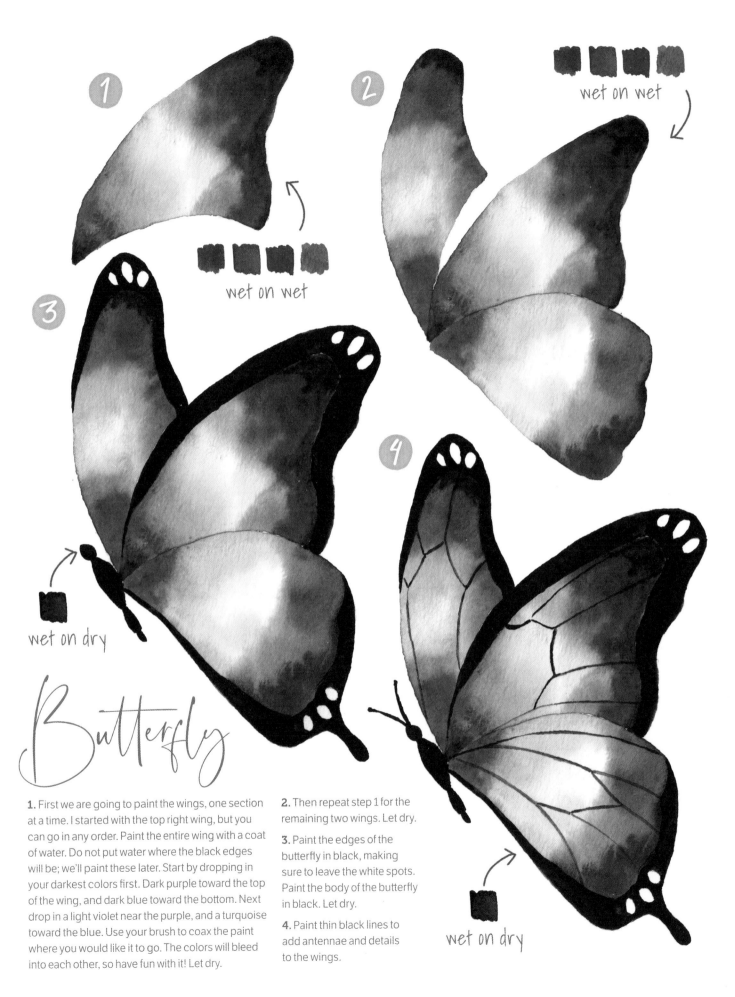

1 wet on wet

2 wet on wet

3 wet on dry

4 wet on dry

Butterfly

1. First we are going to paint the wings, one section at a time. I started with the top right wing, but you can go in any order. Paint the entire wing with a coat of water. Do not put water where the black edges will be; we'll paint these later. Start by dropping in your darkest colors first. Dark purple toward the top of the wing, and dark blue toward the bottom. Next drop in a light violet near the purple, and a turquoise toward the blue. Use your brush to coax the paint where you would like it to go. The colors will bleed into each other, so have fun with it! Let dry.

2. Then repeat step 1 for the remaining two wings. Let dry.

3. Paint the edges of the butterfly in black, making sure to leave the white spots. Paint the body of the butterfly in black. Let dry.

4. Paint thin black lines to add antennae and details to the wings.

BRUSHES

• Medium brush (4, 6)

COLOR PALETTE

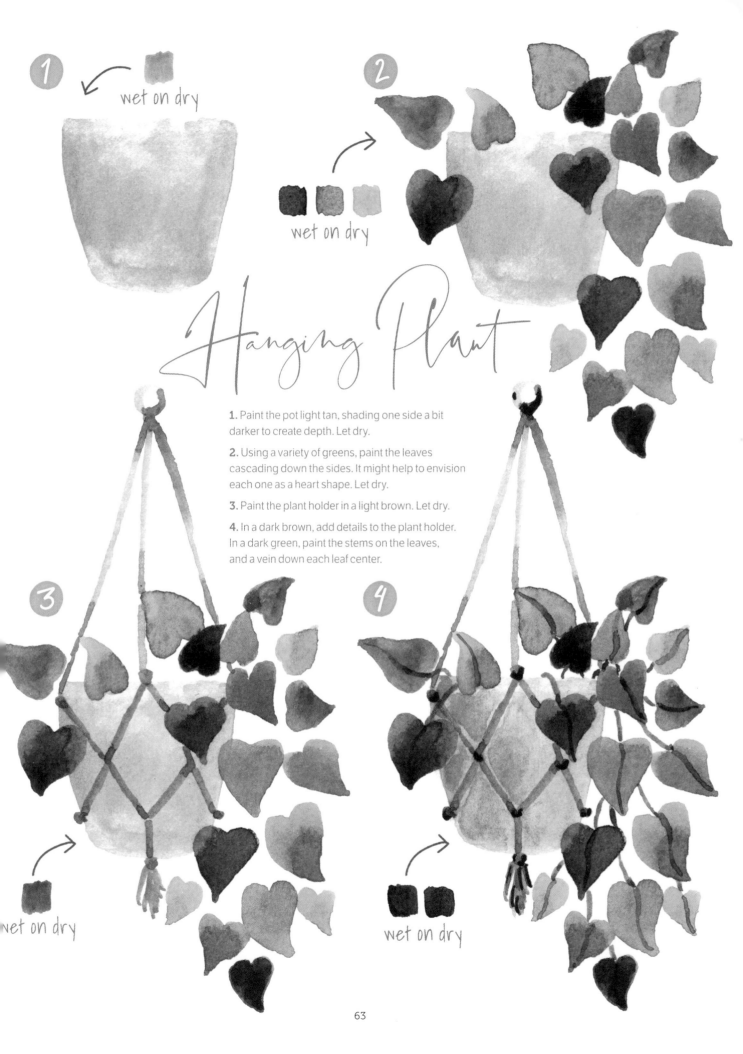

1. wet on dry

2. wet on dry

Hanging Plant

1. Paint the pot light tan, shading one side a bit darker to create depth. Let dry.

2. Using a variety of greens, paint the leaves cascading down the sides. It might help to envision each one as a heart shape. Let dry.

3. Paint the plant holder in a light brown. Let dry.

4. In a dark brown, add details to the plant holder. In a dark green, paint the stems on the leaves, and a vein down each leaf center.

3. wet on dry

4. wet on dry

TIP

Inspiration is everywhere—artwork, books, nature—explore your interests and see what motivates you to create something amazing.

BRUSHES

- Medium/large brush for petals, stem, and leaves (6, 8)
- Small brush for details (3)

COLOR PALETTE

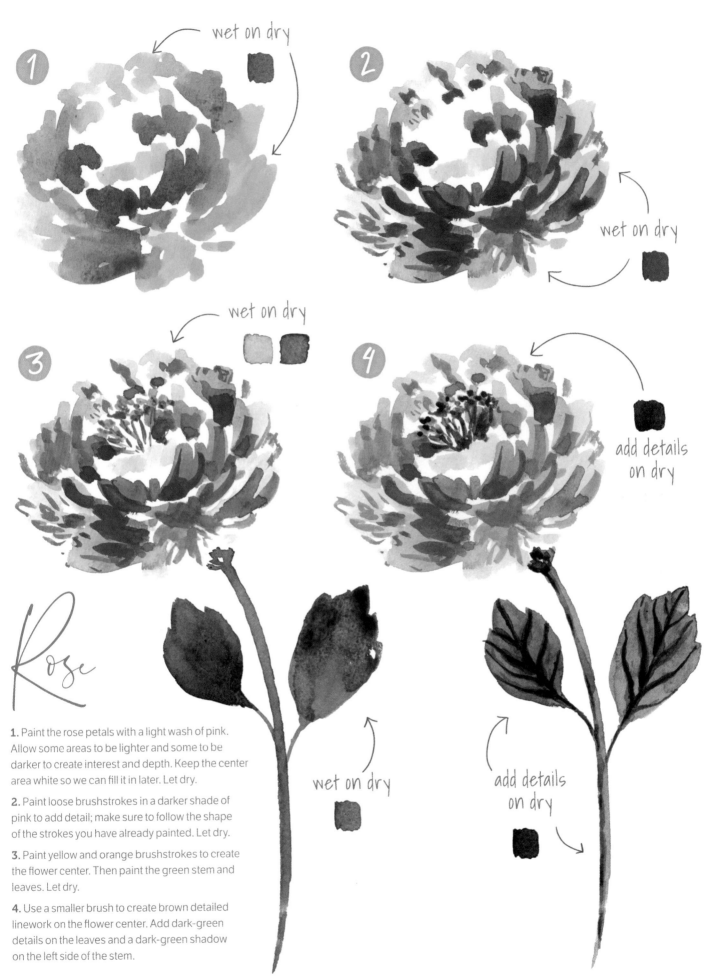

wet on dry

①

② wet on dry

wet on dry

③

④ add details on dry

Rose

wet on dry

add details on dry

1. Paint the rose petals with a light wash of pink. Allow some areas to be lighter and some to be darker to create interest and depth. Keep the center area white so we can fill it in later. Let dry.

2. Paint loose brushstrokes in a darker shade of pink to add detail; make sure to follow the shape of the strokes you have already painted. Let dry.

3. Paint yellow and orange brushstrokes to create the flower center. Then paint the green stem and leaves. Let dry.

4. Use a smaller brush to create brown detailed linework on the flower center. Add dark-green details on the leaves and a dark-green shadow on the left side of the stem.

BRUSHES
• Medium brush (4, 6)

COLOR PALETTE

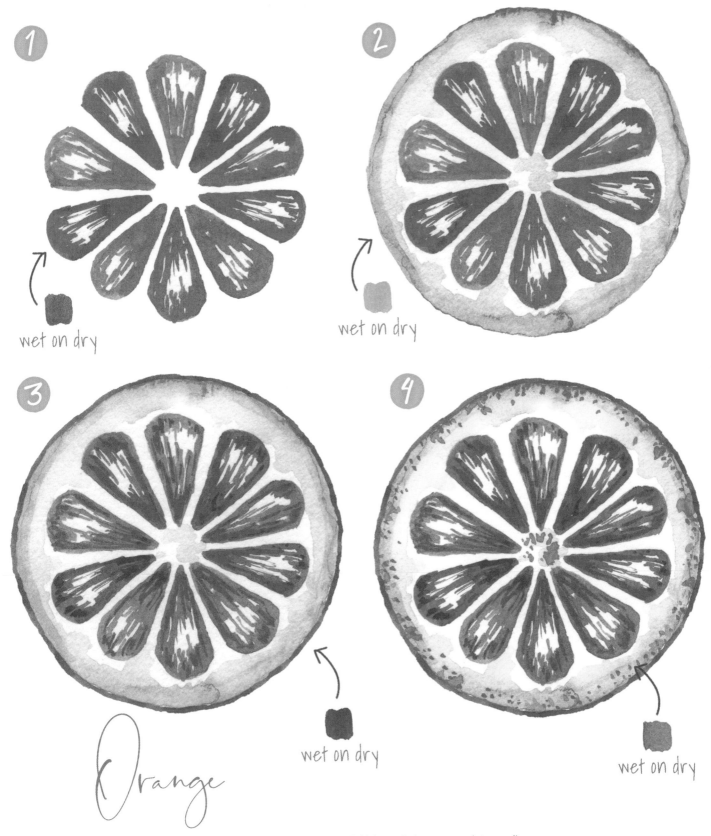

1 wet on dry

2 wet on dry

3 wet on dry

Orange

4 wet on dry

1. Paint the individual segments in orange. Leave areas of white to create highlights. Let dry.

2. Paint a yellow circle around the segments, creating the outer edge of the orange. Using water, smooth the inner edge of the circle to blend into the white area. Paint some yellow dots in the center of the segments. Let dry.

3. Using a dark orange, paint some lines on the individual segments to create texture. In the same color, paint a thin line along the outside edge of the orange. Let dry.

4. In orange, paint some dots in the center and along the inner edge to create texture.

TIP
If your watercolor paint dries
on your palette, it is still good
to use. Just add a little water.

BRUSHES

- Large brush for frosting (8, 10)
- Medium brush for donut and
 details (4, 6)
- Small brush for shadows (2, 3)

COLOR PALETTE

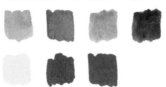

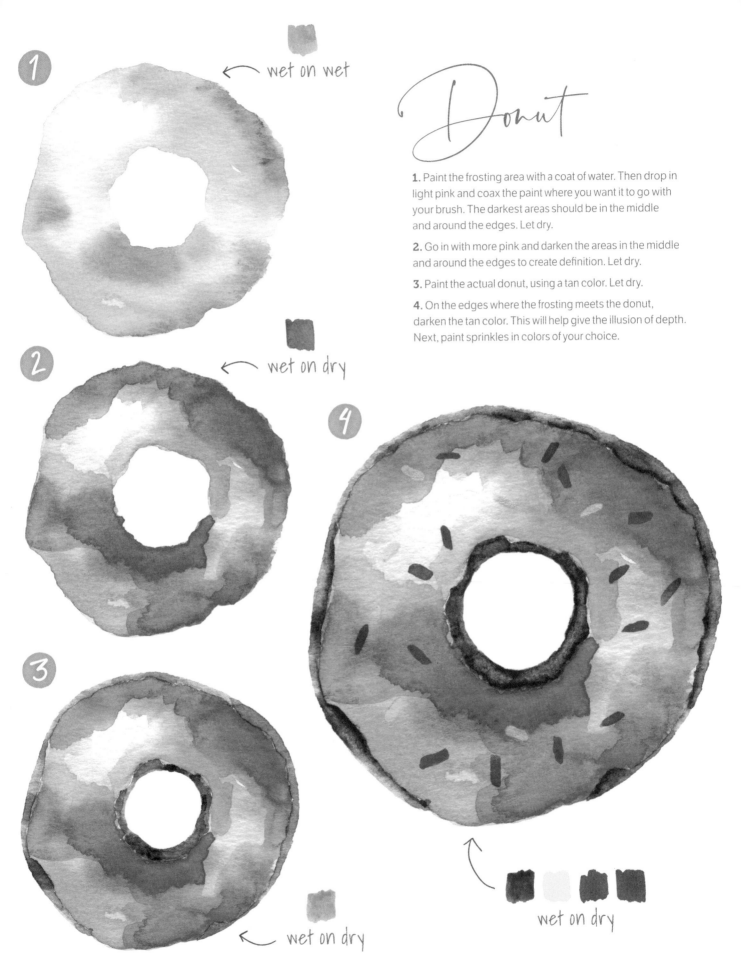

1 ← wet on wet

Donut

1. Paint the frosting area with a coat of water. Then drop in light pink and coax the paint where you want it to go with your brush. The darkest areas should be in the middle and around the edges. Let dry.

2. Go in with more pink and darken the areas in the middle and around the edges to create definition. Let dry.

3. Paint the actual donut, using a tan color. Let dry.

4. On the edges where the frosting meets the donut, darken the tan color. This will help give the illusion of depth. Next, paint sprinkles in colors of your choice.

2 ← wet on dry

4

3 ← wet on dry

← wet on dry

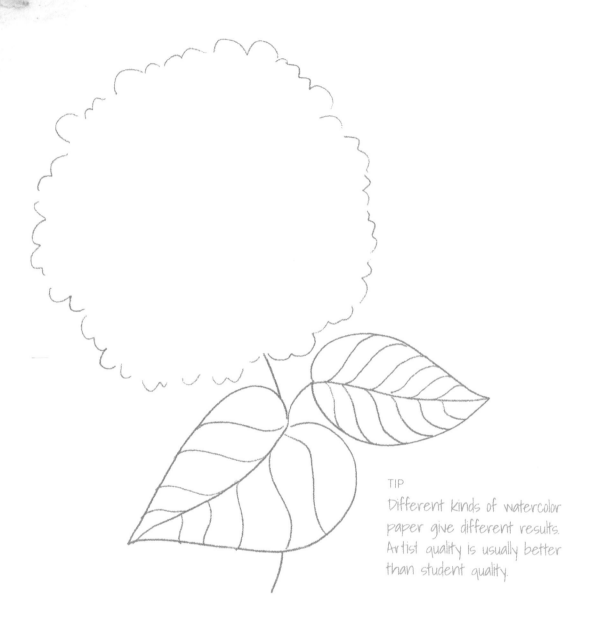

TIP

Different kinds of watercolor paper give different results. Artist quality is usually better than student quality.

BRUSHES
- Medium/large brush for petals and leaves (6, 8)
- Small brush for details (2, 3)

COLOR PALETTE

Hydrangea

1. Using a variety of blues and purples, start in the middle of the flower by painting clusters of 4 petals. Use varying amounts of water to lighten and darken the shades of color.

2. Continue to add petal clusters. The colors will blend into one another, depending on how much water is used. This is what we want! It adds interest and depth to the flower.

3. Continue with this method to add more petal clusters, working outward and creating a circular shape. Let dry.

4. Paint the stem, using a medium green. Then paint leaves by using a combination of greens and blues. Leave some white areas to give the illusion of highlights. Let dry.

5. Paint veins on the leaves in a darker green to add detail. On the flower, paint tiny circles in the middle of each petal cluster in various shades of dark blues and purples.

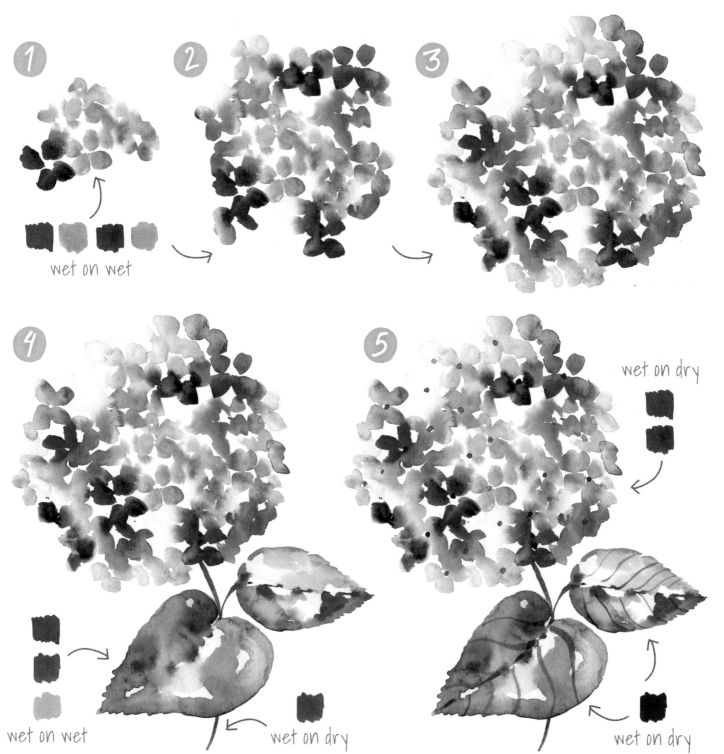

wet on wet

wet on dry

wet on wet

wet on dry

wet on dry

TIP
There are 3 kinds of
watercolor paper: Hot Press
is smooth, Cold Press has a
slight texture, and Rough
Press has the most texture
of the three.

BRUSHES

• Large brush for feather (8, 10)
• Medium brush for details (4, 6)

COLOR PALETTE

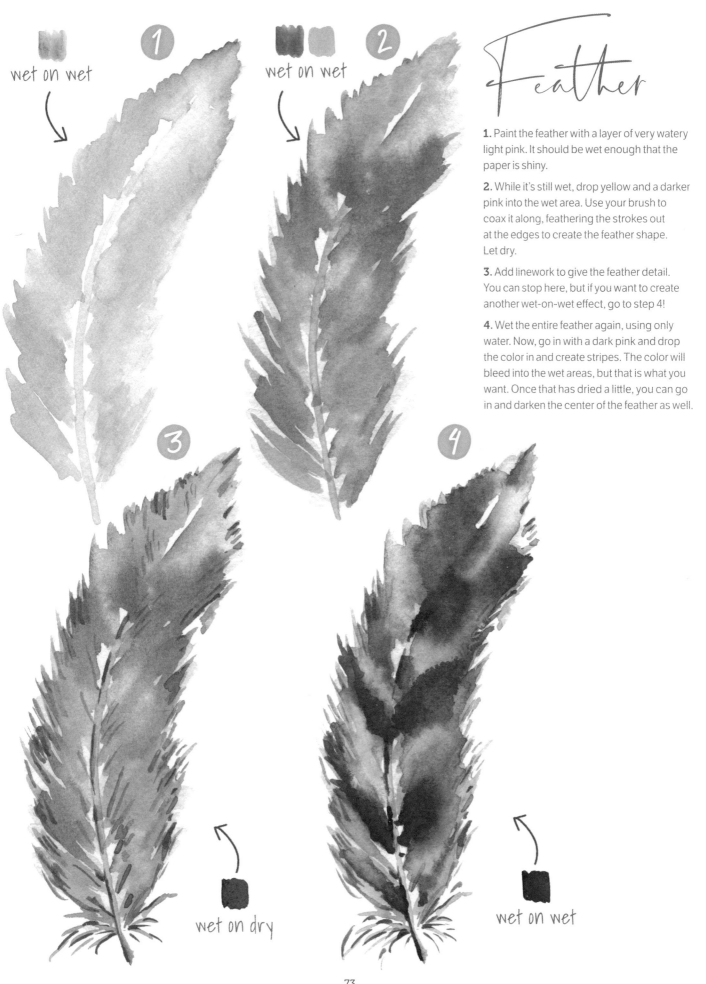

wet on wet

①

wet on wet

②

Feather

1. Paint the feather with a layer of very watery light pink. It should be wet enough that the paper is shiny.

2. While it's still wet, drop yellow and a darker pink into the wet area. Use your brush to coax it along, feathering the strokes out at the edges to create the feather shape. Let dry.

3. Add linework to give the feather detail. You can stop here, but if you want to create another wet-on-wet effect, go to step 4!

4. Wet the entire feather again, using only water. Now, go in with a dark pink and drop the color in and create stripes. The color will bleed into the wet areas, but that is what you want. Once that has dried a little, you can go in and darken the center of the feather as well.

③

④

wet on dry

wet on wet

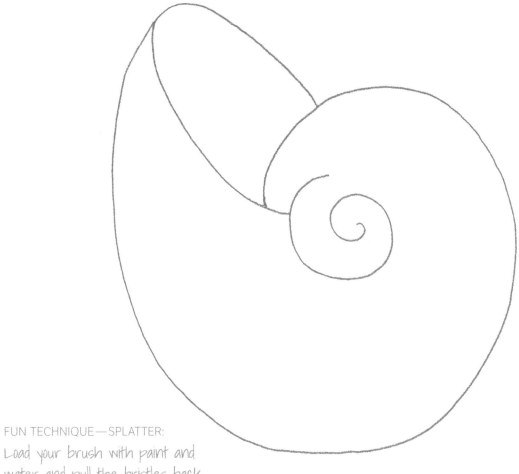

FUN TECHNIQUE—SPLATTER:
Load your brush with paint and water and pull the bristles back with your fingers. Then release the bristles and let the paint "splatter" onto the paper.

BRUSHES
• Large brush for shell (8, 10)
• Medium brush for stripes (4, 6)
• Small brush for details (3)

COLOR PALETTE

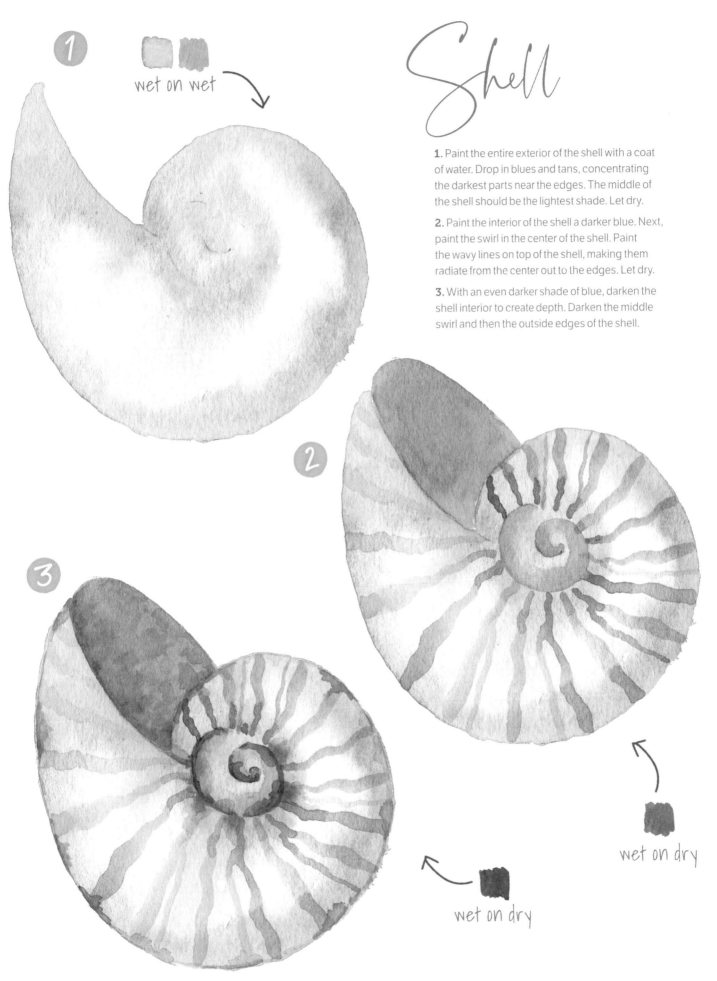

wet on wet

Shell

1. Paint the entire exterior of the shell with a coat of water. Drop in blues and tans, concentrating the darkest parts near the edges. The middle of the shell should be the lightest shade. Let dry.

2. Paint the interior of the shell a darker blue. Next, paint the swirl in the center of the shell. Paint the wavy lines on top of the shell, making them radiate from the center out to the edges. Let dry.

3. With an even darker shade of blue, darken the shell interior to create depth. Darken the middle swirl and then the outside edges of the shell.

wet on dry

wet on dry

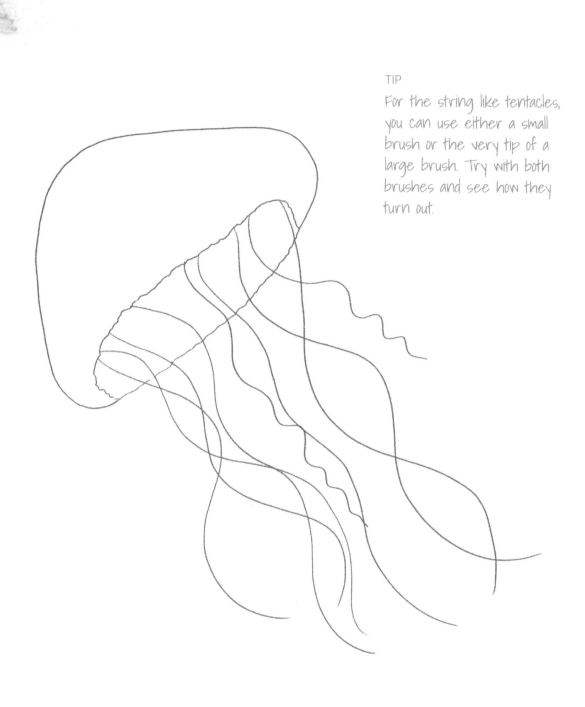

TIP

For the string like tentacles, you can use either a small brush or the very tip of a large brush. Try with both brushes and see how they turn out.

BRUSHES

- Medium/large brush for steps 1 and 2 (6, 8)
- Large brush for step 3 (10)
- Small brush or the tip of a larger brush for step 4 (2, 3)

COLOR PALETTE

Jellyfish

1. Paint the top of the jellyfish body with a coat of water. Drop in paints in different shades of blue and green. Concentrate the darkest blue along the bottom edge. Let dry.

2. Paint the underside of the jellyfish with a coat of water. Drop in dark blue along the bottom edge and coax it along so it blends upward. Let dry.

3. Paint the inner tentacles, using light blues and greens. Let dry.

4. Paint the stringy tentacles in dark blues and dark greens.

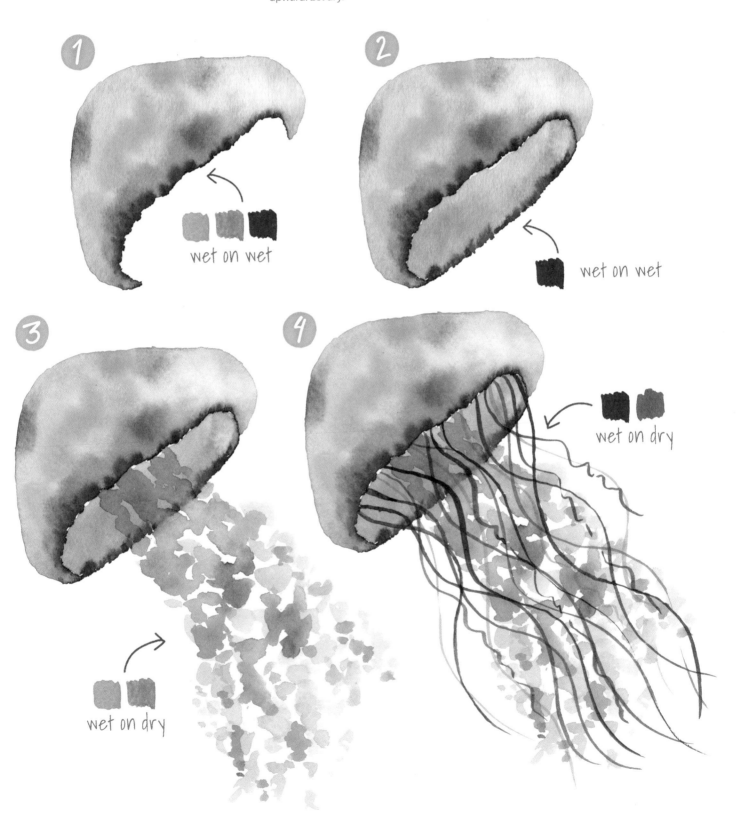

wet on wet

wet on wet

wet on dry

wet on dry

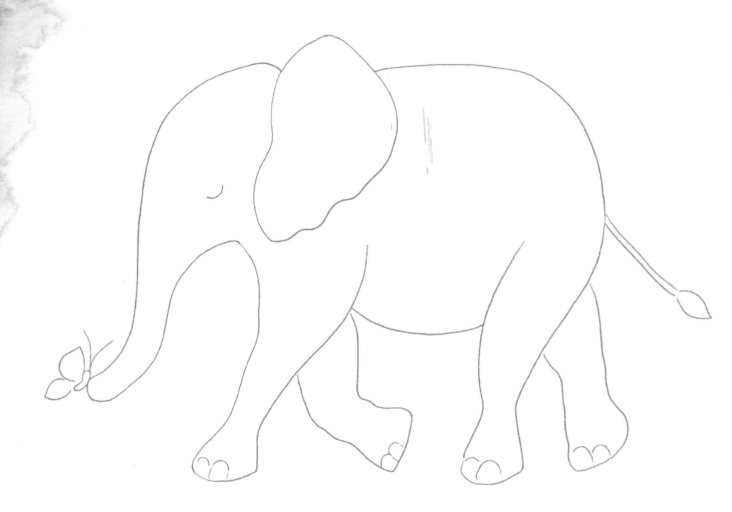

BRUSHES

- Large brush for body (8, 10)
- Small brush for details (2, 3)

COLOR PALETTE

Elephant

1. Paint the entire elephant, except the toenails, with a heavy coat of water. Drop in light gray and coax the paint where you want it to go. While it's still wet, add in a small amount of light pink and yellow. There is no wrong way to do this; the bright colors will help add interest. Let dry.

2. In a medium gray, darken some areas of the elephant to create depth. Darken the edges of the ear, the bottom of the stomach, and the edges of the legs and trunk. The back legs should be the darkest because they are farthest from us. Blend your paint into the rest of the elephant to avoid hard edges. Let dry.

3. Add the finishing details. In the same medium gray, paint the eye, tail, and toenails. Using a fine brush, paint wrinkles in the trunk and legs. Using the same gray, yellow, and pink from step 1, paint a butterfly on the tip of the trunk.

1

wet on wet

2

wet on dry

3

wet on dry

TIP

It's helpful to keep a piece
of scrap paper next to you
to test your colors.

BRUSHES
- Medium/large brush (6, 8)
- Small brush for details (2, 3)

COLOR PALETTE

Margarita

1. Paint the margarita section with a coat of water. Drop in reds and pinks and coax the paint where you want it to go with your brush. Make sure to leave a white area for a highlight. Let dry.

2. Using a very soft bluish gray, paint the first layer of the glass. Next, paint the lime slice, using a light green for the inside and a dark green for the rind. Let dry.

3. Using a slightly darker shade of your bluish gray, add shadows to the glass. Paint little dots along the glass rim for salt. Add detail to the lime slice, using darker greens. Let dry.

4. Darken your glass one last time with a darker shade of blue green. Then darken the reds of the margarita, making sure to blend the color into the existing paint so that you don't get hard edges.

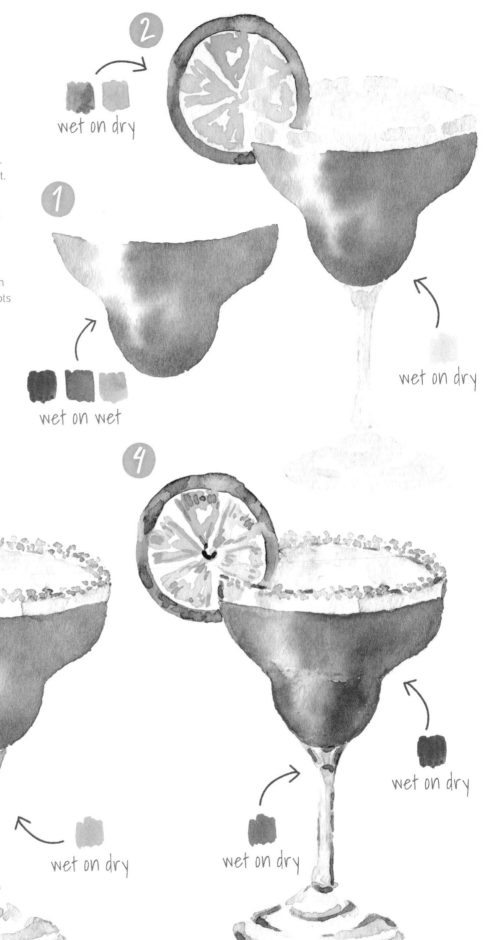

wet on dry

wet on wet

wet on dry

wet on dry

wet on dry

wet on dry

wet on dry

81

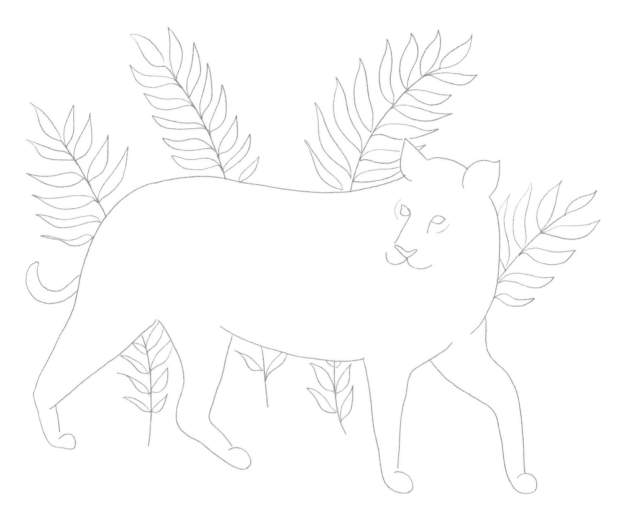

TIP

Listen to music that inspires
you while you paint.

 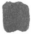

BRUSHES

- Medium/large brush
 for tiger body (6, 8)
- Medium brush for
 stripes and leaves (4, 6)
- Small brush for details (3)

COLOR PALETTE

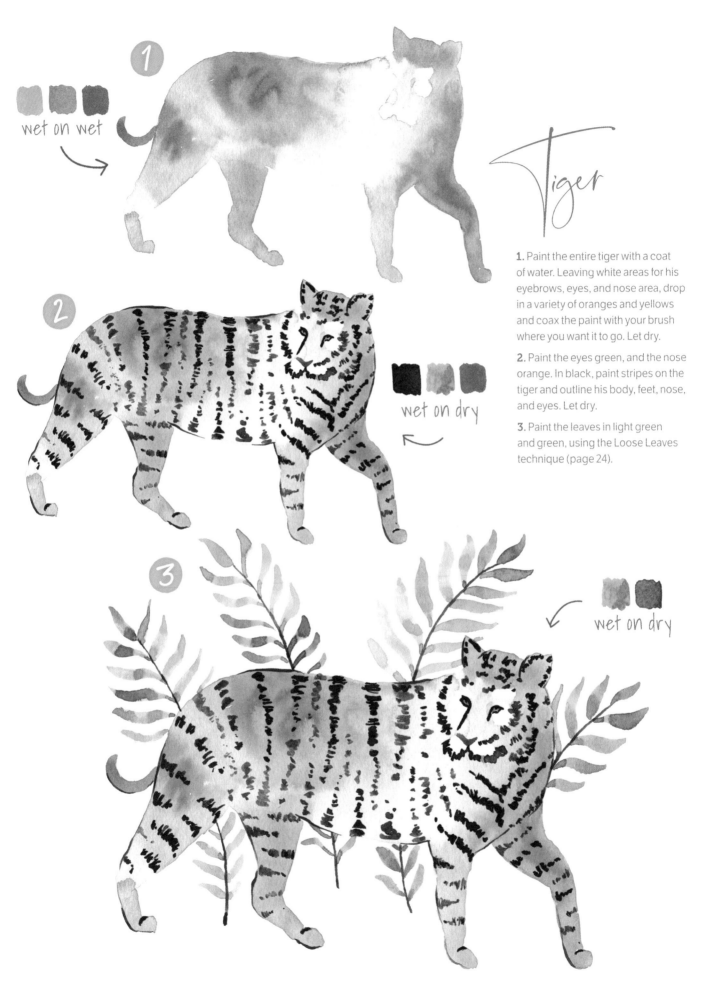

wet on wet

Tiger

1. Paint the entire tiger with a coat of water. Leaving white areas for his eyebrows, eyes, and nose area, drop in a variety of oranges and yellows and coax the paint with your brush where you want it to go. Let dry.

2. Paint the eyes green, and the nose orange. In black, paint stripes on the tiger and outline his body, feet, nose, and eyes. Let dry.

3. Paint the leaves in light green and green, using the Loose Leaves technique (page 24).

wet on dry

wet on dry

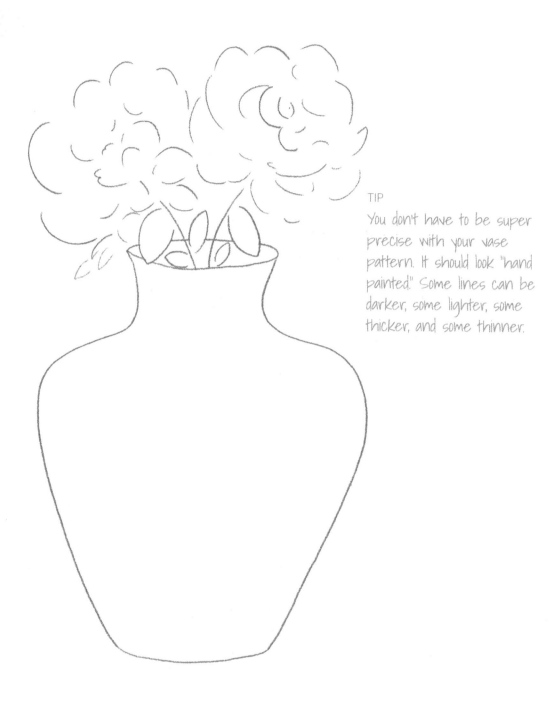

TIP

You don't have to be super precise with your vase pattern. It should look "hand painted." Some lines can be darker, some lighter, some thicker, and some thinner.

BRUSHES

- Medium brush (4, 6)
- Small brush for vase design (2, 3)

COLOR PALETTE

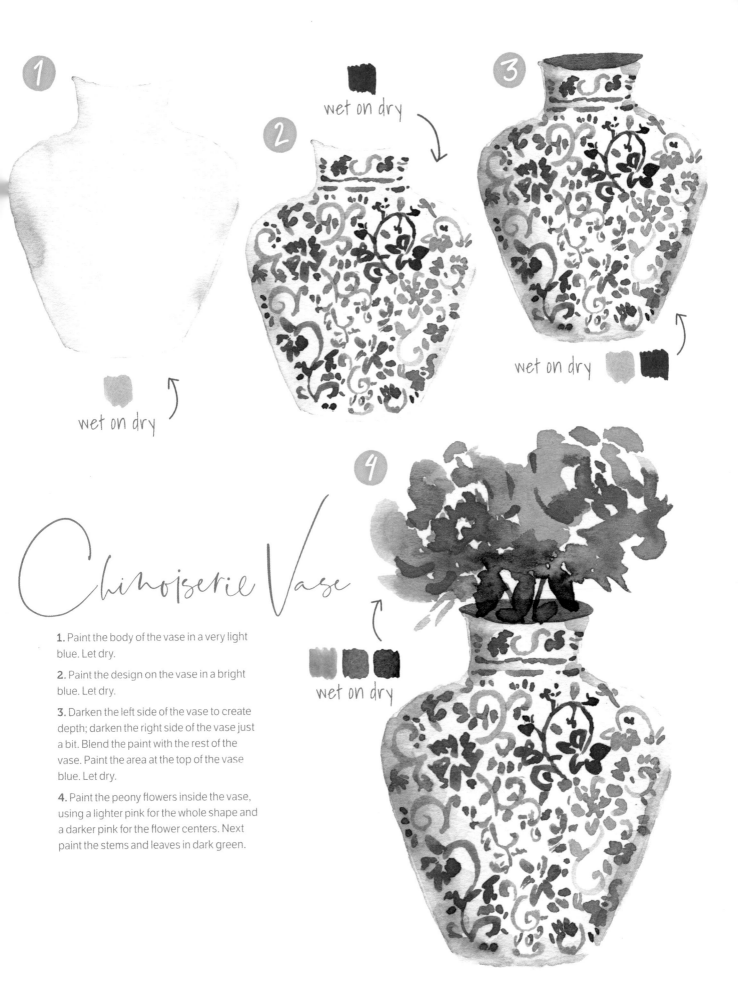

1 wet on dry

2 wet on dry

3 wet on dry

Chinoiserie Vase

4 wet on dry

1. Paint the body of the vase in a very light blue. Let dry.

2. Paint the design on the vase in a bright blue. Let dry.

3. Darken the left side of the vase to create depth; darken the right side of the vase just a bit. Blend the paint with the rest of the vase. Paint the area at the top of the vase blue. Let dry.

4. Paint the peony flowers inside the vase, using a lighter pink for the whole shape and a darker pink for the flower centers. Next paint the stems and leaves in dark green.

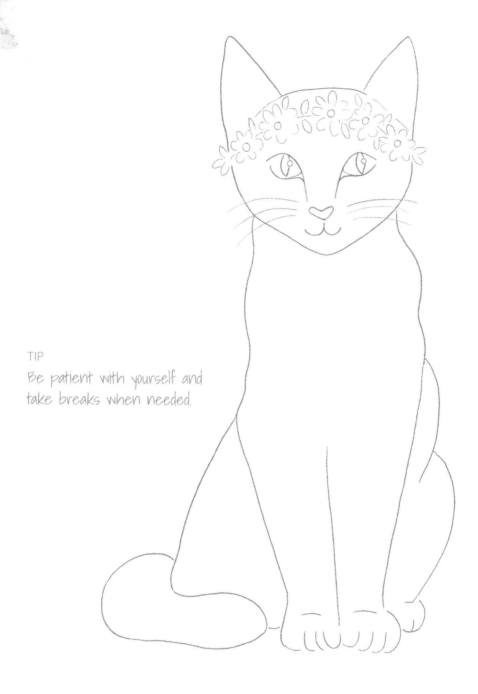

TIP

Be patient with yourself and take breaks when needed.

BRUSHES

- Medium brush for body and fur (4, 6)
- Small brush for face details and flower crown (2, 3)

COLOR PALETTE

Cat

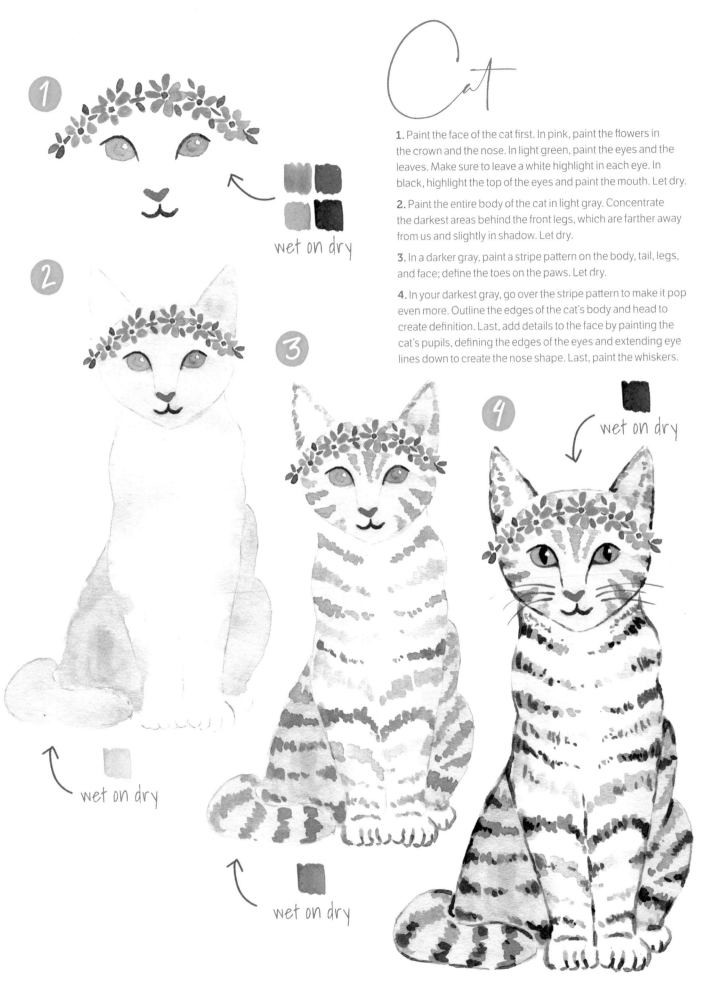

1. Paint the face of the cat first. In pink, paint the flowers in the crown and the nose. In light green, paint the eyes and the leaves. Make sure to leave a white highlight in each eye. In black, highlight the top of the eyes and paint the mouth. Let dry.

2. Paint the entire body of the cat in light gray. Concentrate the darkest areas behind the front legs, which are farther away from us and slightly in shadow. Let dry.

3. In a darker gray, paint a stripe pattern on the body, tail, legs, and face; define the toes on the paws. Let dry.

4. In your darkest gray, go over the stripe pattern to make it pop even more. Outline the edges of the cat's body and head to create definition. Last, add details to the face by painting the cat's pupils, defining the edges of the eyes and extending eye lines down to create the nose shape. Last, paint the whiskers.

wet on dry

wet on dry

wet on dry

wet on dry

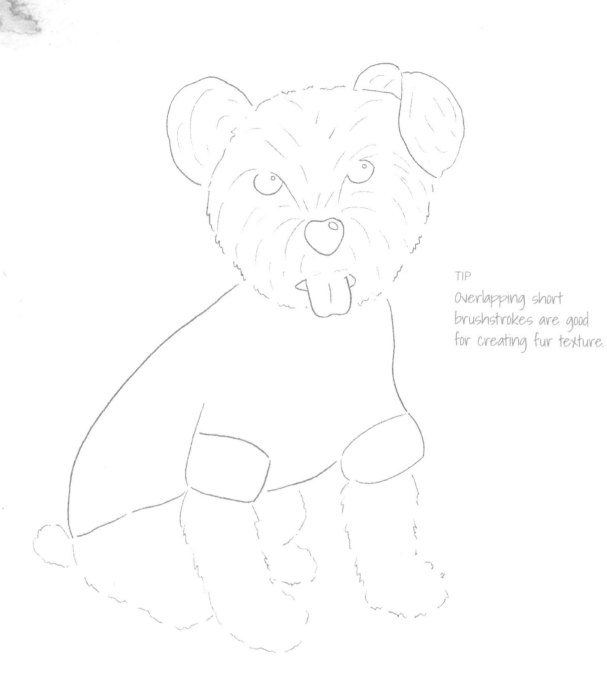

TIP

Overlapping short brushstrokes are good for creating fur texture.

BRUSHES

- Medium brush for fur and sweater (4, 6)
- Small brush for face, eyes, nose, and mouth (2, 3)

COLOR PALETTE

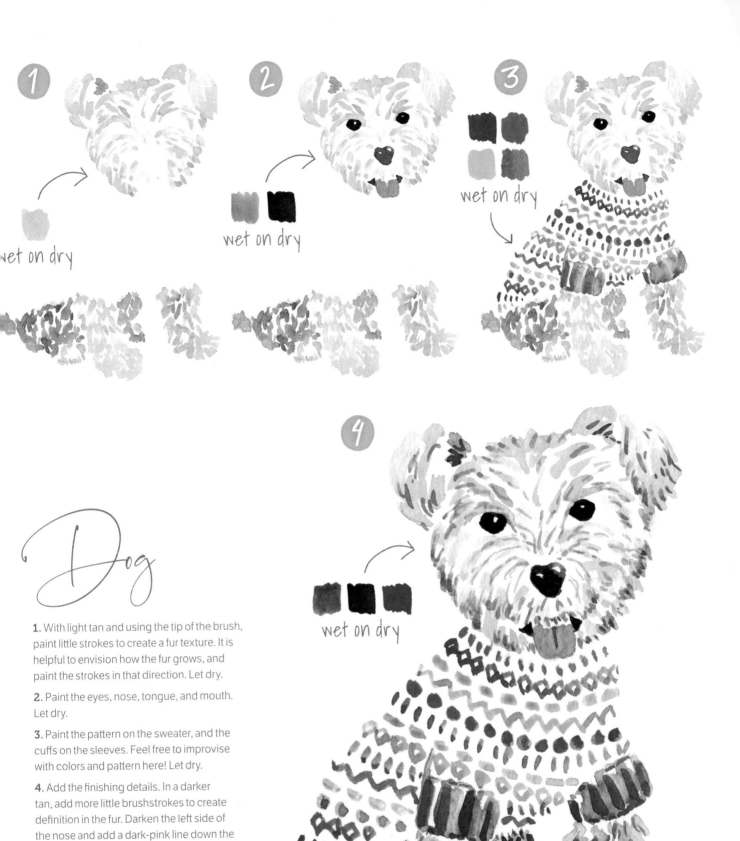

wet on dry

wet on dry

wet on dry

wet on dry

Dog

1. With light tan and using the tip of the brush, paint little strokes to create a fur texture. It is helpful to envision how the fur grows, and paint the strokes in that direction. Let dry.

2. Paint the eyes, nose, tongue, and mouth. Let dry.

3. Paint the pattern on the sweater, and the cuffs on the sleeves. Feel free to improvise with colors and pattern here! Let dry.

4. Add the finishing details. In a darker tan, add more little brushstrokes to create definition in the fur. Darken the left side of the nose and add a dark-pink line down the middle of the tongue. Darken the sleeves of the sweater if they need more definition.

BRUSHES

- Medium brush for body (4, 6)
- Small brush for details (2, 3)

COLOR PALETTE

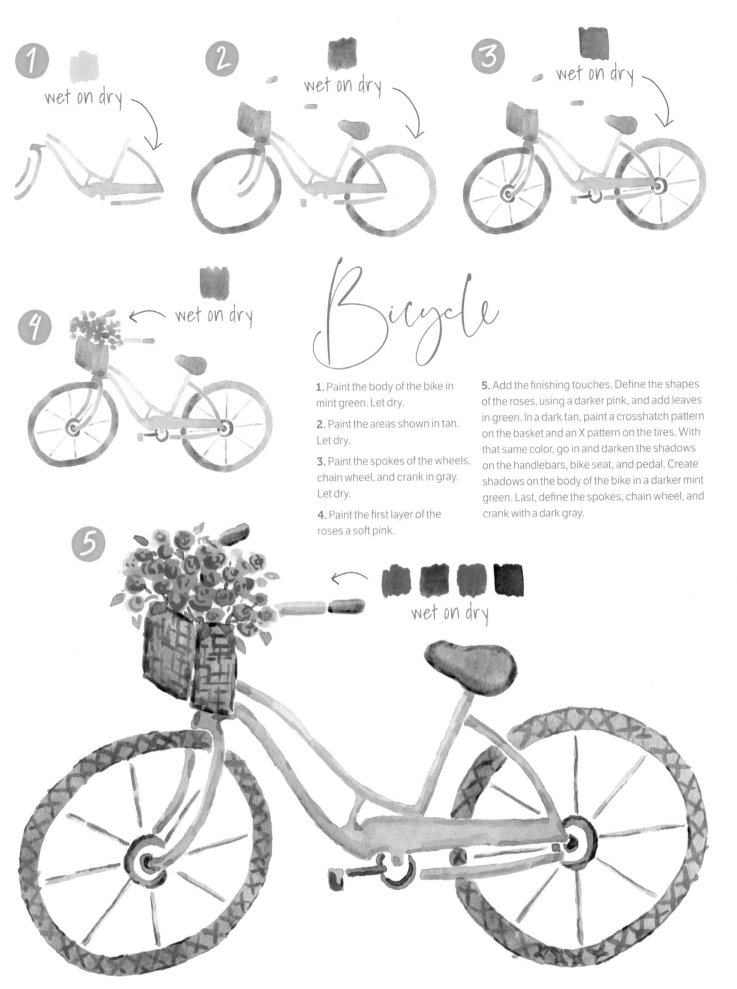

1. wet on dry

2. wet on dry

3. wet on dry

4. wet on dry

Bicycle

1. Paint the body of the bike in mint green. Let dry.

2. Paint the areas shown in tan. Let dry.

3. Paint the spokes of the wheels, chain wheel, and crank in gray. Let dry.

4. Paint the first layer of the roses a soft pink.

5. Add the finishing touches. Define the shapes of the roses, using a darker pink, and add leaves in green. In a dark tan, paint a crosshatch pattern on the basket and an X pattern on the tires. With that same color, go in and darken the shadows on the handlebars, bike seat, and pedal. Create shadows on the body of the bike in a darker mint green. Last, define the spokes, chain wheel, and crank with a dark gray.

5. wet on dry

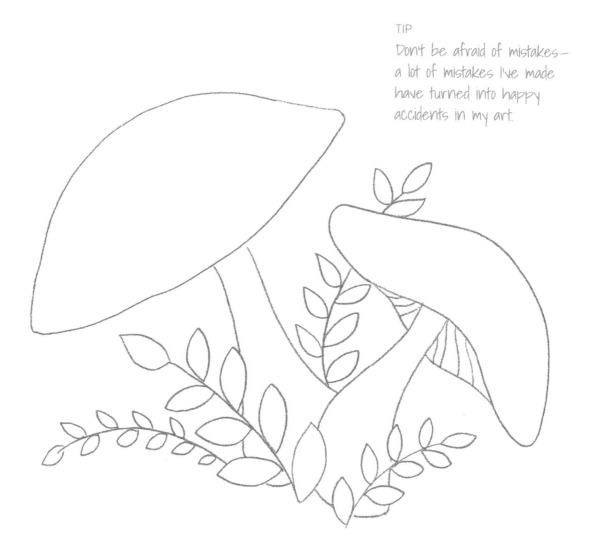

TIP
Don't be afraid of mistakes—
a lot of mistakes I've made
have turned into happy
accidents in my art.

BRUSHES

- Medium brush for mushroom (4, 6)
- Small brush for details and leaves (2, 3)

COLOR PALETTE

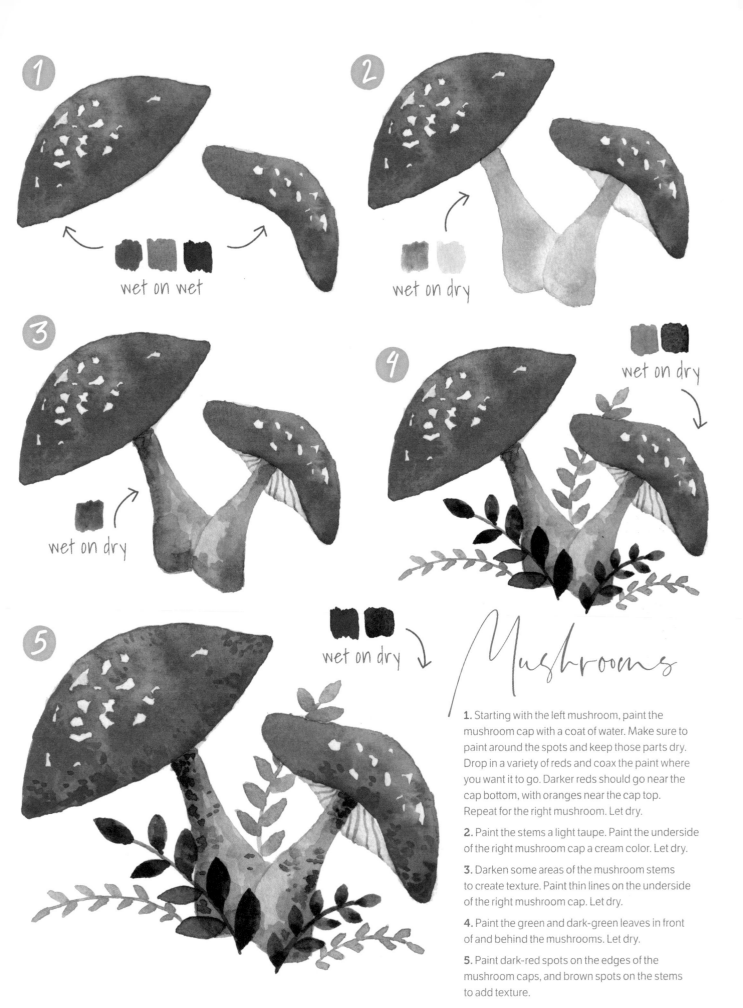

1. Starting with the left mushroom, paint the mushroom cap with a coat of water. Make sure to paint around the spots and keep those parts dry. Drop in a variety of reds and coax the paint where you want it to go. Darker reds should go near the cap bottom, with oranges near the cap top. Repeat for the right mushroom. Let dry.

2. Paint the stems a light taupe. Paint the underside of the right mushroom cap a cream color. Let dry.

3. Darken some areas of the mushroom stems to create texture. Paint thin lines on the underside of the right mushroom cap. Let dry.

4. Paint the green and dark-green leaves in front of and behind the mushrooms. Let dry.

5. Paint dark-red spots on the edges of the mushroom caps, and brown spots on the stems to add texture.

Mushrooms

wet on wet

wet on dry

wet on dry

wet on dry

wet on dry

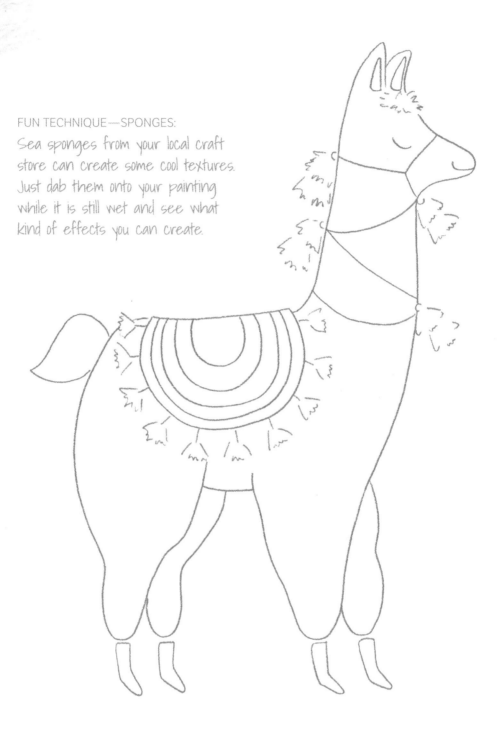

FUN TECHNIQUE—SPONGES:

Sea sponges from your local craft store can create some cool textures. Just dab them onto your painting while it is still wet and see what kind of effects you can create.

BRUSHES

- Medium brush (4, 6)
- Small brush for details (2, 3)

COLOR PALETTE

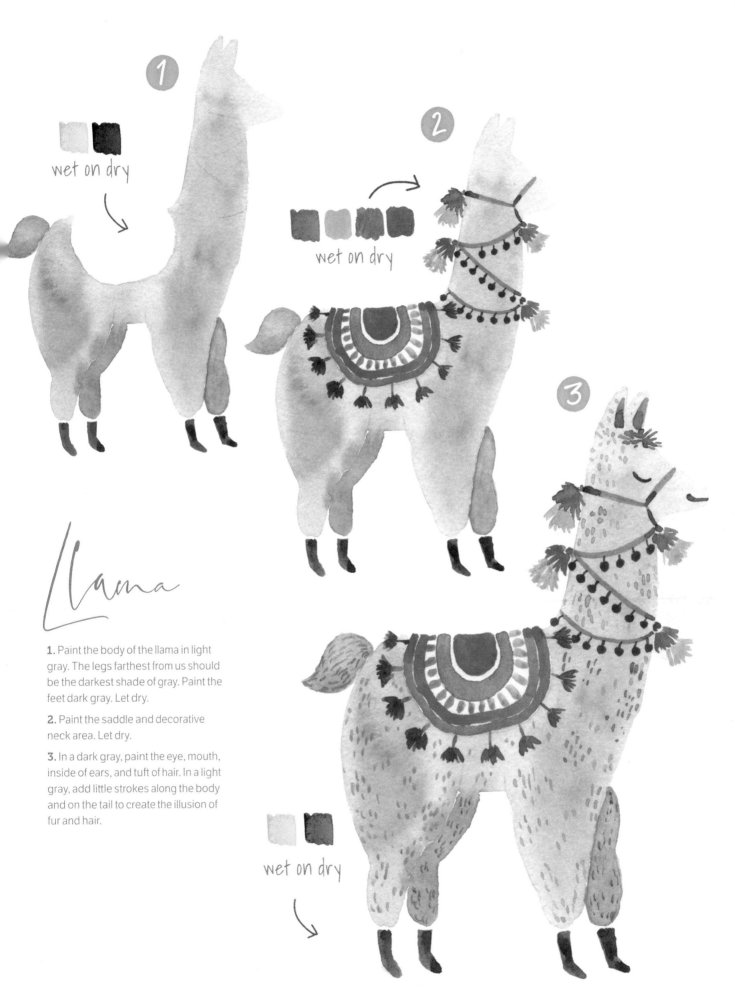

Llama

1. Paint the body of the llama in light gray. The legs farthest from us should be the darkest shade of gray. Paint the feet dark gray. Let dry.

2. Paint the saddle and decorative neck area. Let dry.

3. In a dark gray, paint the eye, mouth, inside of ears, and tuft of hair. In a light gray, add little strokes along the body and on the tail to create the illusion of fur and hair.

wet on dry

wet on dry

wet on dry

BRUSHES

- Medium brush (4, 6)
- Small brush for details (2, 3)

COLOR PALETTE

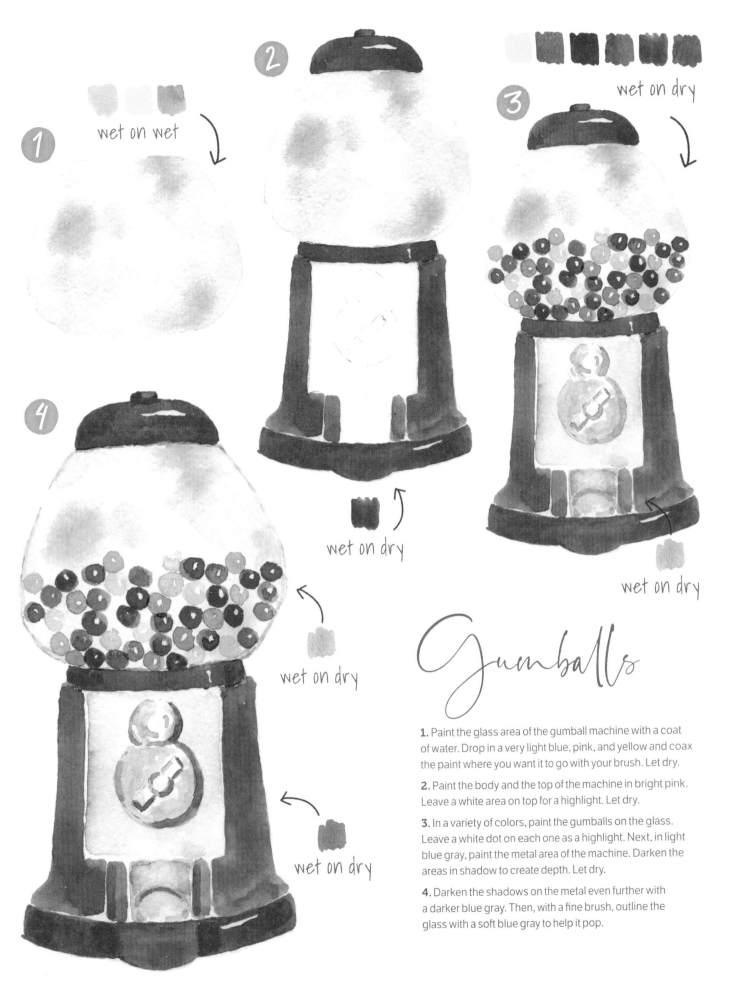

1

wet on wet

2

wet on dry

3

wet on dry

wet on dry

4

wet on dry

wet on dry

Gumballs

1. Paint the glass area of the gumball machine with a coat of water. Drop in a very light blue, pink, and yellow and coax the paint where you want it to go with your brush. Let dry.

2. Paint the body and the top of the machine in bright pink. Leave a white area on top for a highlight. Let dry.

3. In a variety of colors, paint the gumballs on the glass. Leave a white dot on each one as a highlight. Next, in light blue gray, paint the metal area of the machine. Darken the areas in shadow to create depth. Let dry.

4. Darken the shadows on the metal even further with a darker blue gray. Then, with a fine brush, outline the glass with a soft blue gray to help it pop.

TIP
Practice, practice, practice!
Keep all of your artwork
so you can see your
improvement over time.

BRUSHES

- Large brush for skull (8, 10)
- Medium brush for floral elements (4, 6)
- Small brush for details (3)

COLOR PALETTE

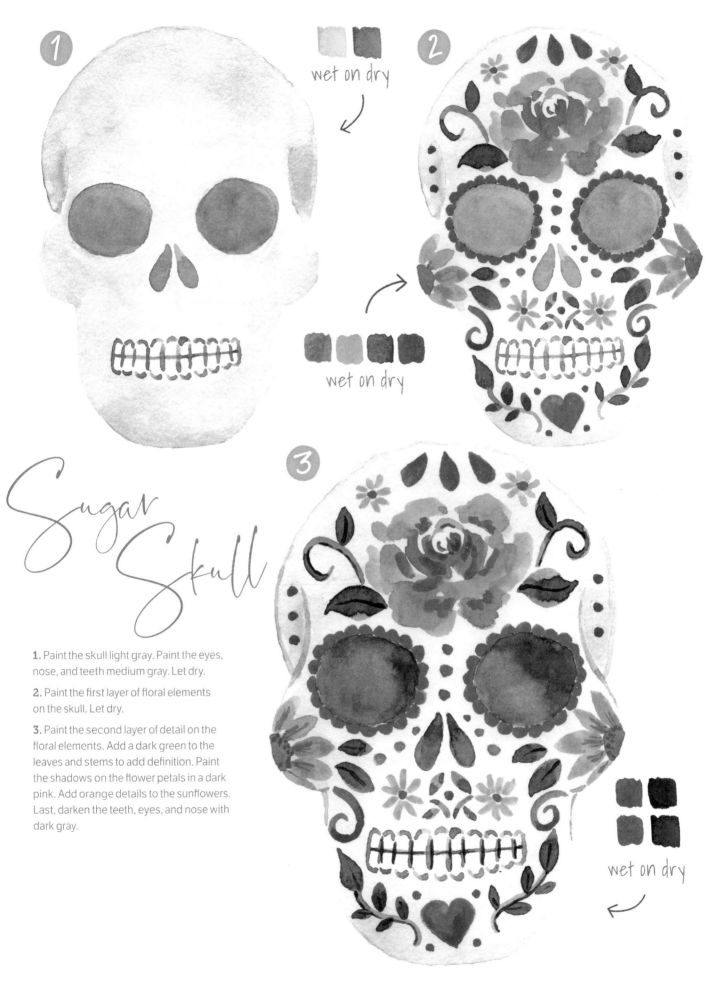

① ② ③

wet on dry

wet on dry

wet on dry

Sugar Skull

1. Paint the skull light gray. Paint the eyes, nose, and teeth medium gray. Let dry.

2. Paint the first layer of floral elements on the skull. Let dry.

3. Paint the second layer of detail on the floral elements. Add a dark green to the leaves and stems to add definition. Paint the shadows on the flower petals in a dark pink. Add orange details to the sunflowers. Last, darken the teeth, eyes, and nose with dark gray.

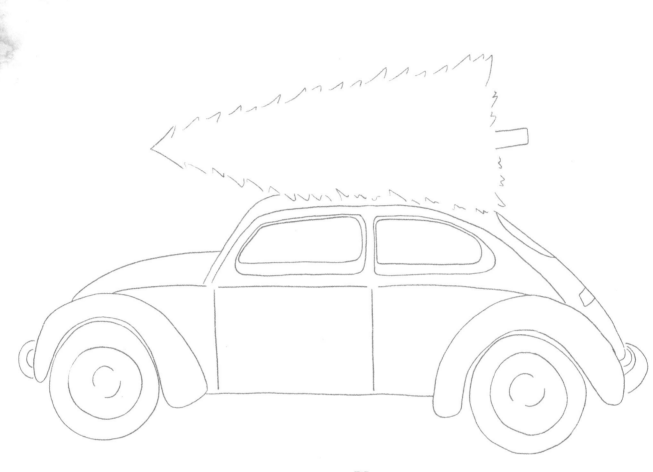

TIP

If your paint is taking too long to dry, use a blow dryer on the low setting and hold it directly above your painting. Don't hold it at an angle or your paint might run all the way across the page!

BRUSHES

- Large/medium brush for body of car (6, 8)
- Small brush for details (2, 3)
- Large/medium brush for tree (6, 8)

COLOR PALETTE

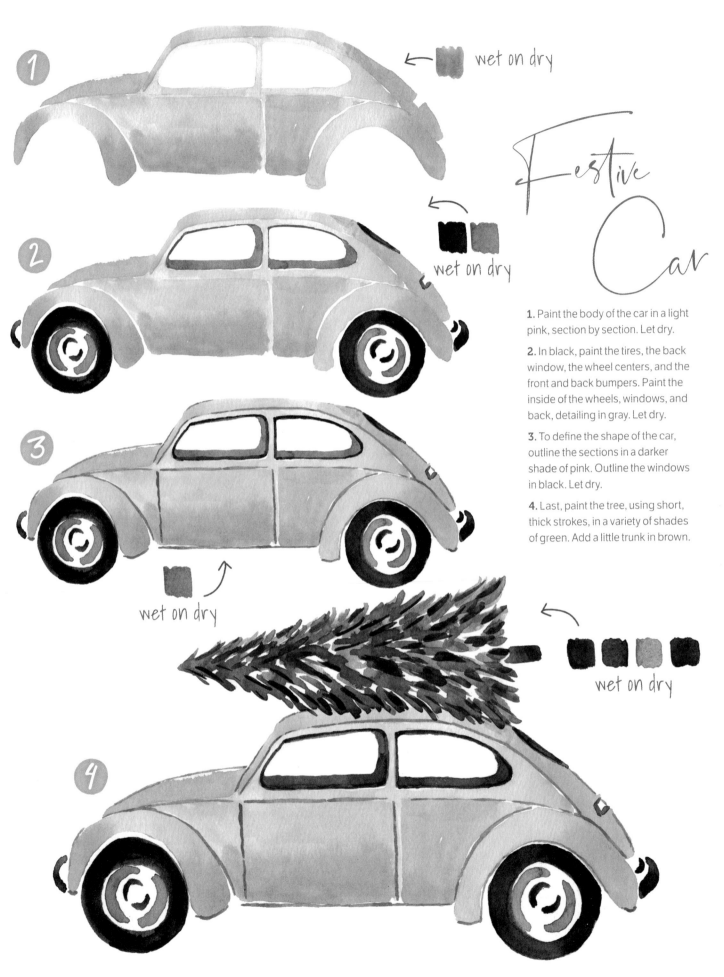

1 → wet on dry

2 ← wet on dry

Festive Car

1. Paint the body of the car in a light pink, section by section. Let dry.

2. In black, paint the tires, the back window, the wheel centers, and the front and back bumpers. Paint the inside of the wheels, windows, and back, detailing in gray. Let dry.

3. To define the shape of the car, outline the sections in a darker shade of pink. Outline the windows in black. Let dry.

4. Last, paint the tree, using short, thick strokes, in a variety of shades of green. Add a little trunk in brown.

3 ↑ wet on dry

← wet on dry

4

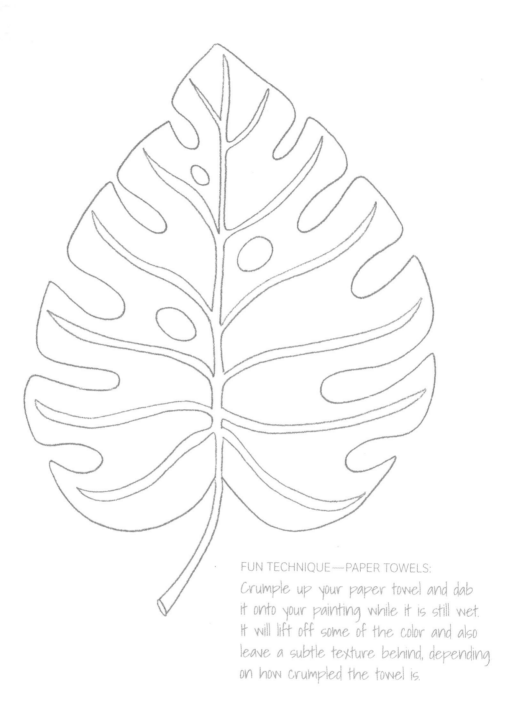

FUN TECHNIQUE—PAPER TOWELS:
Crumple up your paper towel and dab it onto your painting while it is still wet. It will lift off some of the color and also leave a subtle texture behind, depending on how crumpled the towel is.

BRUSHES

- Large brush for leaf (8, 10)
- Medium brush for details (4, 6)

COLOR PALETTE

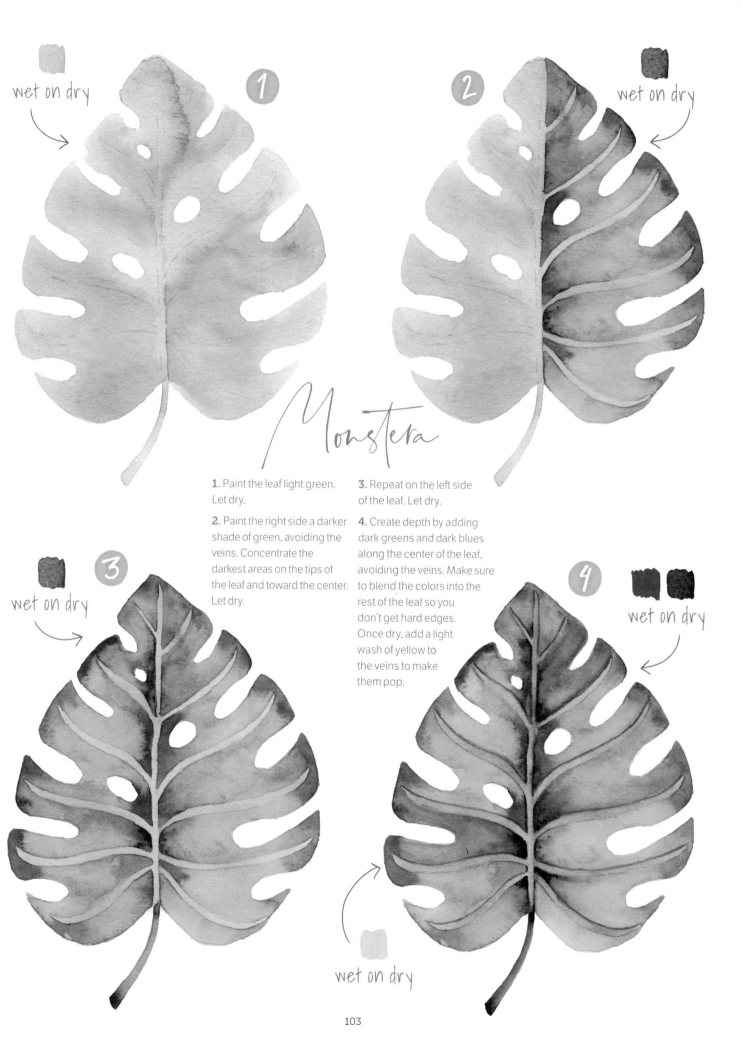

wet on dry

1

2

wet on dry

Monstera

1. Paint the leaf light green. Let dry.

2. Paint the right side a darker shade of green, avoiding the veins. Concentrate the darkest areas on the tips of the leaf and toward the center. Let dry.

3. Repeat on the left side of the leaf. Let dry.

4. Create depth by adding dark greens and dark blues along the center of the leaf, avoiding the veins. Make sure to blend the colors into the rest of the leaf so you don't get hard edges. Once dry, add a light wash of yellow to the veins to make them pop.

wet on dry

3

4

wet on dry

wet on dry

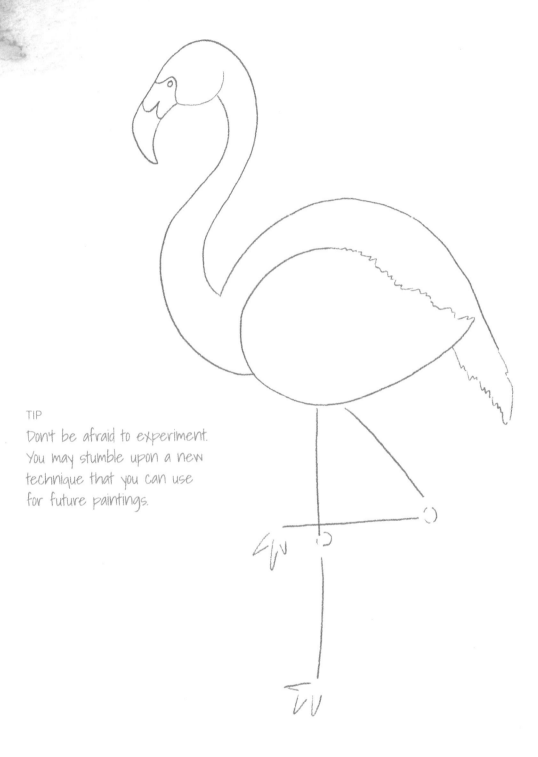

TIP

Don't be afraid to experiment. You may stumble upon a new technique that you can use for future paintings.

BRUSHES

- Medium brush for body, feathers, and legs (6)
- Small brush for beak and eye (2, 3)

COLOR PALETTE

 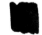

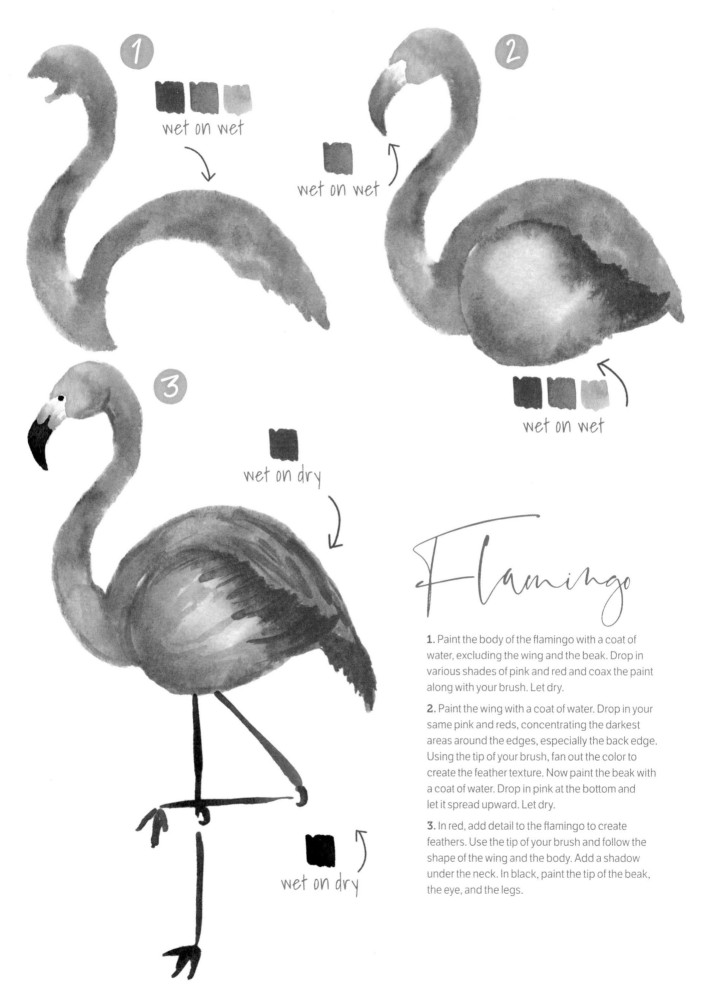

1

wet on wet

2

wet on wet

wet on wet

3

wet on dry

wet on dry

Flamingo

1. Paint the body of the flamingo with a coat of water, excluding the wing and the beak. Drop in various shades of pink and red and coax the paint along with your brush. Let dry.

2. Paint the wing with a coat of water. Drop in your same pink and reds, concentrating the darkest areas around the edges, especially the back edge. Using the tip of your brush, fan out the color to create the feather texture. Now paint the beak with a coat of water. Drop in pink at the bottom and let it spread upward. Let dry.

3. In red, add detail to the flamingo to create feathers. Use the tip of your brush and follow the shape of the wing and the body. Add a shadow under the neck. In black, paint the tip of the beak, the eye, and the legs.

FUN TECHNIQUE—SALT:

Sprinkle salt onto an area of wet paint. Allow paper to dry completely. Then lightly brush away the salt with your finger. You'll be left with interesting bursts and star textures!

BRUSHES

- Medium brush for body (4, 6)
- Small brush for details (3)

COLOR PALETTE

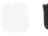

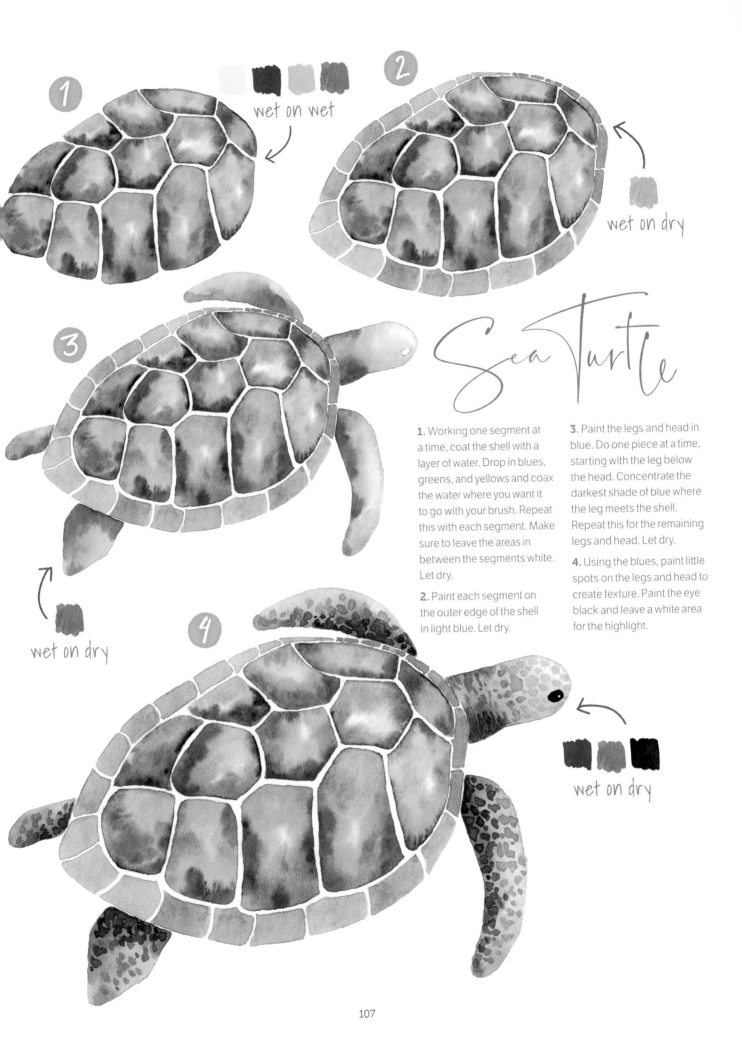

1 wet on wet

2 wet on dry

3 wet on dry

4

Sea Turtle

1. Working one segment at a time, coat the shell with a layer of water. Drop in blues, greens, and yellows and coax the water where you want it to go with your brush. Repeat this with each segment. Make sure to leave the areas in between the segments white. Let dry.

2. Paint each segment on the outer edge of the shell in light blue. Let dry.

3. Paint the legs and head in blue. Do one piece at a time, starting with the leg below the head. Concentrate the darkest shade of blue where the leg meets the shell. Repeat this for the remaining legs and head. Let dry.

4. Using the blues, paint little spots on the legs and head to create texture. Paint the eye black and leave a white area for the highlight.

wet on dry

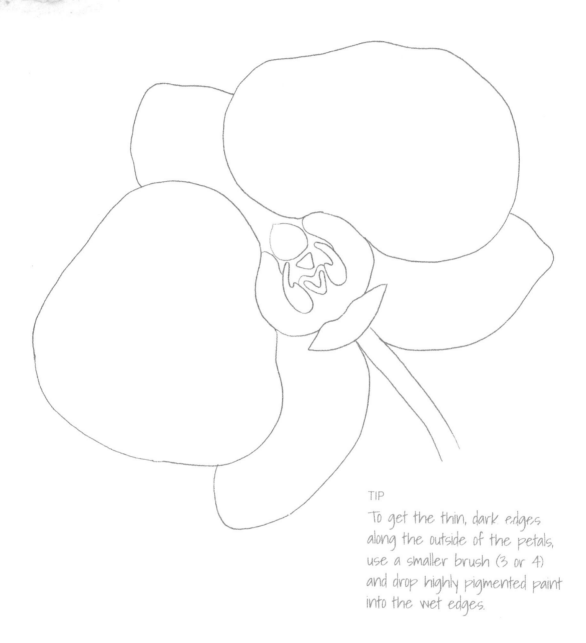

TIP

To get the thin, dark edges along the outside of the petals, use a smaller brush (3 or 4) and drop highly pigmented paint into the wet edges.

BRUSHES

- Large brush for petals (8, 10)
- Small/medium brush for details (3, 4)

COLOR PALETTE

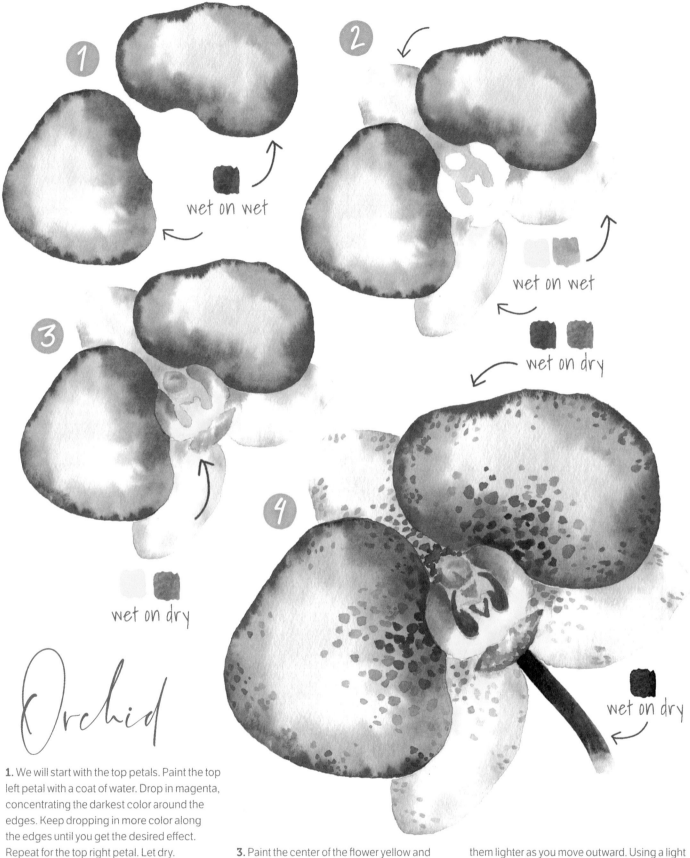

1 wet on wet

2 wet on wet

wet on dry

3 wet on dry

4 wet on dry

Orchid

1. We will start with the top petals. Paint the top left petal with a coat of water. Drop in magenta, concentrating the darkest color around the edges. Keep dropping in more color along the edges until you get the desired effect. Repeat for the top right petal. Let dry.

2. Now for the back petals. Paint the top petal with a coat of water. Drop in light pink and light yellow; coax the paint where you want it to go. Make sure to extend the pink into the center as shown. Repeat with the other two petals. Let dry.

3. Paint the center of the flower yellow and light pink. The yellow area should be in the very center, while the remaining areas are pink. Let dry.

4. Using magenta, paint spots along the center and edges of the top petals. The darkest spots should be near the center. Gradually paint them lighter as you move outward. Using a light magenta, paint spots on the back petals. Now go in with the magenta and add details to the flower center. Last, paint the stem in dark green. Fade out the bottom edge with water to avoid a hard line.

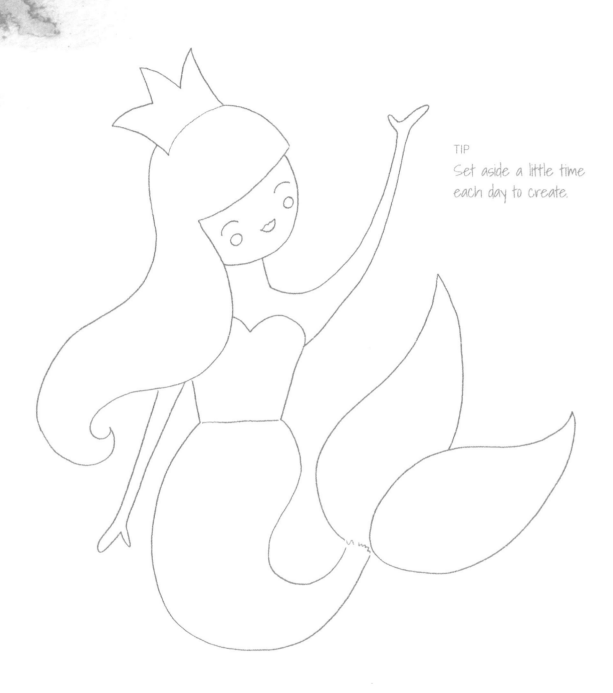

TIP
Set aside a little time
each day to create.

BRUSHES

- Medium/large brush for tail (6, 8)
- Medium brush for body (4, 6)
- Small brush for details (2, 3)

COLOR PALETTE

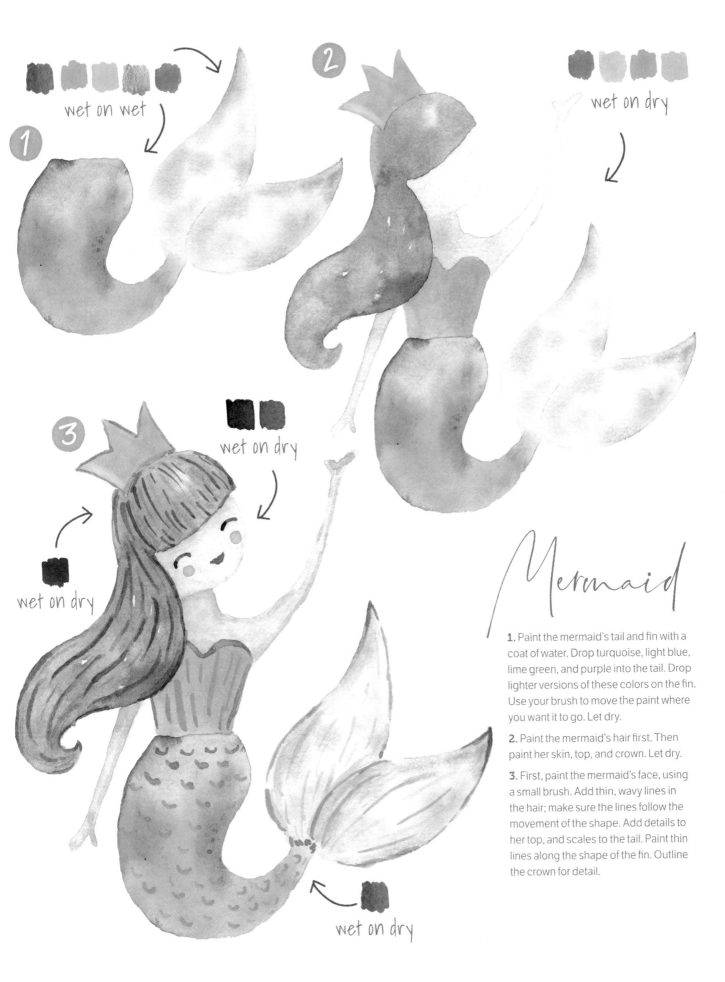

wet on wet

1

2

wet on dry

3

wet on dry

wet on dry

wet on dry

Mermaid

1. Paint the mermaid's tail and fin with a coat of water. Drop turquoise, light blue, lime green, and purple into the tail. Drop lighter versions of these colors on the fin. Use your brush to move the paint where you want it to go. Let dry.

2. Paint the mermaid's hair first. Then paint her skin, top, and crown. Let dry.

3. First, paint the mermaid's face, using a small brush. Add thin, wavy lines in the hair; make sure the lines follow the movement of the shape. Add details to her top, and scales to the tail. Paint thin lines along the shape of the fin. Outline the crown for detail.

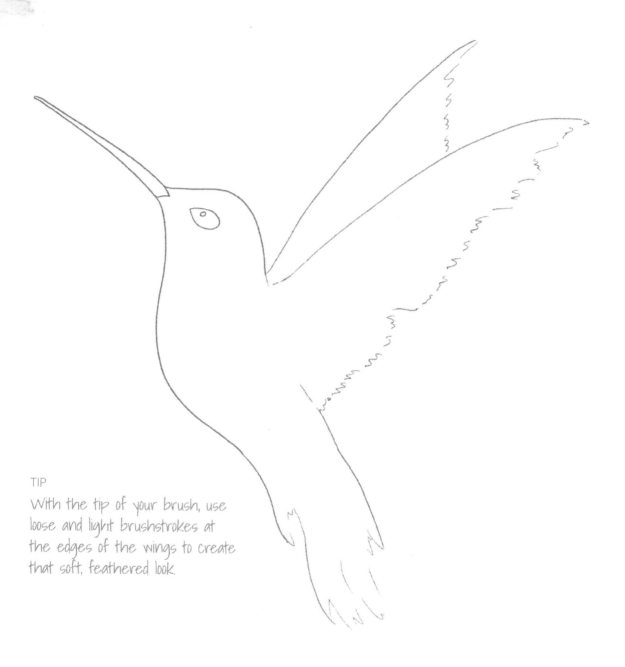

TIP

With the tip of your brush, use loose and light brushstrokes at the edges of the wings to create that soft, feathered look.

BRUSHES

- Large brush for body (8, 10)
- Medium brush for wing and body details (4, 6)
- Small brush for eye and beak (2, 3)

COLOR PALETTE

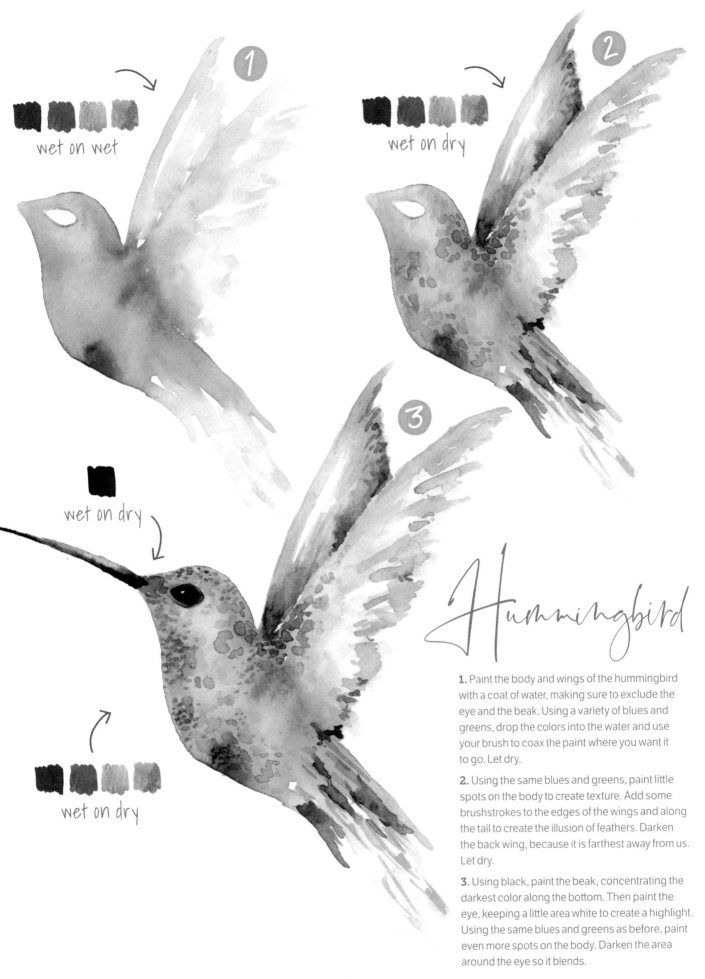

wet on wet

wet on dry

wet on dry

wet on dry

Hummingbird

1. Paint the body and wings of the hummingbird with a coat of water, making sure to exclude the eye and the beak. Using a variety of blues and greens, drop the colors into the water and use your brush to coax the paint where you want it to go. Let dry.

2. Using the same blues and greens, paint little spots on the body to create texture. Add some brushstrokes to the edges of the wings and along the tail to create the illusion of feathers. Darken the back wing, because it is farthest away from us. Let dry.

3. Using black, paint the beak, concentrating the darkest color along the bottom. Then paint the eye, keeping a little area white to create a highlight. Using the same blues and greens as before, paint even more spots on the body. Darken the area around the eye so it blends.

TIP
Blend, blend, blend! The key
to creating the smooth, round
shape of this lemon is blending
out your paint edges with water.

BRUSHES

• Medium brush (4, 6)
• Small brush for details (2, 3)

COLOR PALETTE

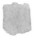

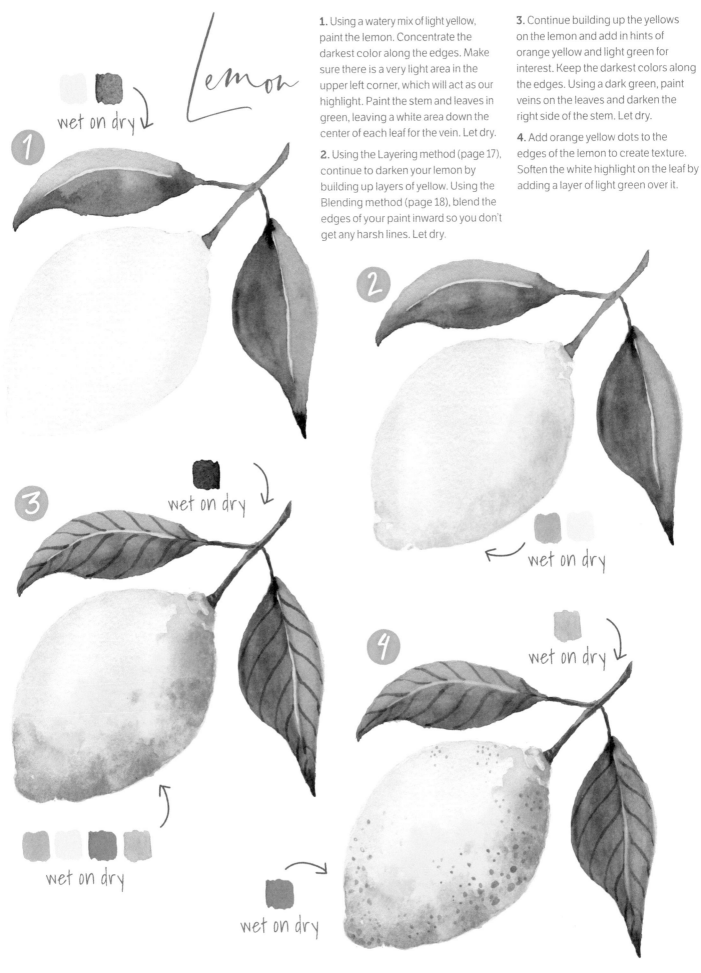

Lemon

wet on dry

1

1. Using a watery mix of light yellow, paint the lemon. Concentrate the darkest color along the edges. Make sure there is a very light area in the upper left corner, which will act as our highlight. Paint the stem and leaves in green, leaving a white area down the center of each leaf for the vein. Let dry.

2. Using the Layering method (page 17), continue to darken your lemon by building up layers of yellow. Using the Blending method (page 18), blend the edges of your paint inward so you don't get any harsh lines. Let dry.

3. Continue building up the yellows on the lemon and add in hints of orange yellow and light green for interest. Keep the darkest colors along the edges. Using a dark green, paint veins on the leaves and darken the right side of the stem. Let dry.

4. Add orange yellow dots to the edges of the lemon to create texture. Soften the white highlight on the leaf by adding a layer of light green over it.

2

wet on dry

3

wet on dry

wet on dry

4

wet on dry

wet on dry

115

BRUSHES

- Medium brush (6)
- Small brush for details (3)

COLOR PALETTE

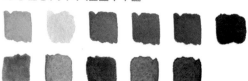

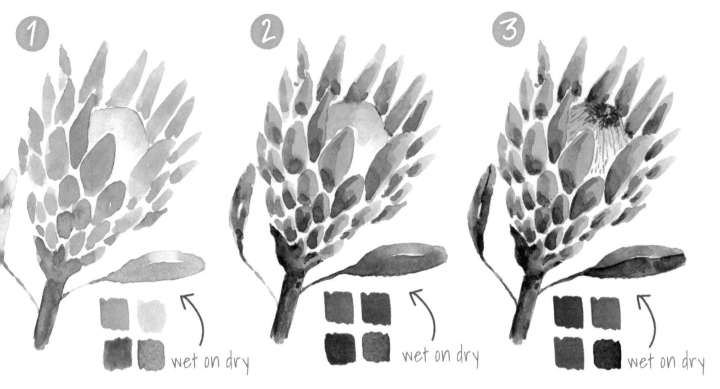

wet on dry

wet on dry

wet on dry

Protea

1. Paint the petals, using a light pink. Paint the center of the flower in a light tan. Paint the stem and leaves, using light brown and green. It is OK if the colors bleed into one another. Let dry.

2. Using darker pinks and reds, darken the bottoms of the petals to create depth. Darken the left side of the center, using pink, and blend to avoid a hard line. Darken the leaves and the left side of the stem with dark green. Let dry.

3. Continue darkening the bottoms of the petals, the leaves, and the left side of the stem by building up layers of paint. Let dry. Once it's dry, add details to the middle of the flower, using a fine brush. Add a dark-green vein down the middle of each leaf. Let dry.

4. Using a dark brown, darken the very bottom of the petals one last time. You need only a tiny bit of brown for this; it should be very subtle. Then darken the dots in the very center of the flower. Last, darken the left side of the stem one more time with brown.

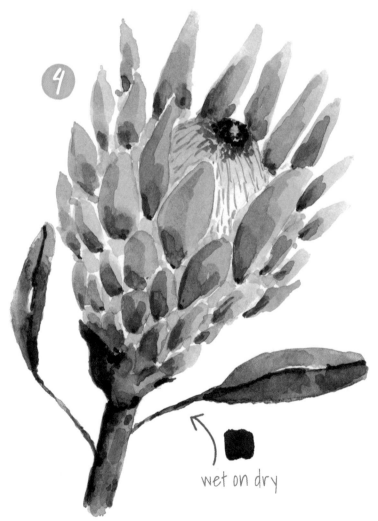

wet on dry

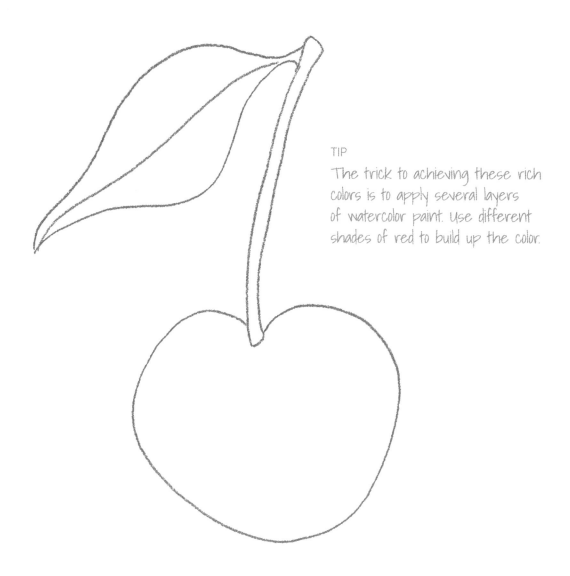

TIP
The trick to achieving these rich colors is to apply several layers of watercolor paint. Use different shades of red to build up the color.

BRUSHES

- Medium brush for body (4, 6)
- Small brush for leaf details (2, 3)

COLOR PALETTE

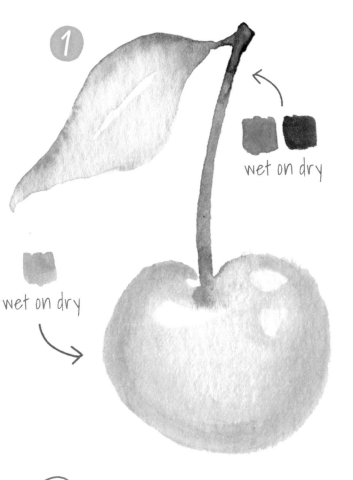

① wet on dry

wet on dry

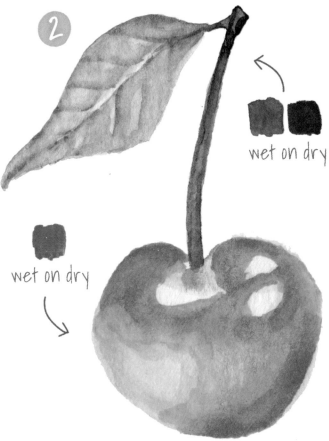

② wet on dry

wet on dry

Cherry

1. Dilute your red color until it is a light shade of pink, then paint the cherry. Leave 3 white areas along the top to create highlights. Next, paint the stem light green and add a brown tip at the top. From there, paint the leaf in light green. Let dry.

2. Go in and darken some areas of the cherry, using a darker shade of the same red. Use the Layering method (page 17) and blend the darker areas of red into your lighter areas. Keep the highlight areas white. Next, take a darker green and add some darker areas to the leaf to create depth and veining. On the stem, add some dark green along the right side to create depth, and some dark brown along the tip to add detail. Let dry.

3. Continue layering shades of red on the cherry to create depth and accentuate the round shape. You can use various shades of red, such as a warm orange red and a cool purplish red. Use the Blending method (page 18) to blend your darker reds into the lighter areas to avoid hard edges. Darken the right side of the stem again to create depth. On the leaf, add dark-green veins for detail.

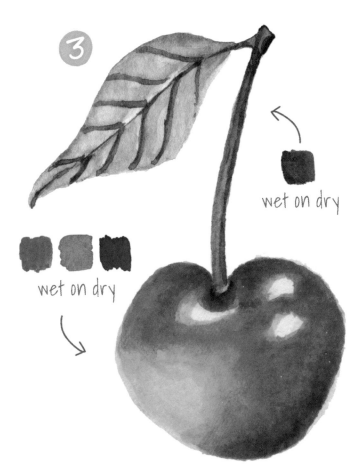

③ wet on dry

wet on dry

BRUSHES

- Medium brush (4, 6)
- Small brush for details (3)

COLOR PALETTE

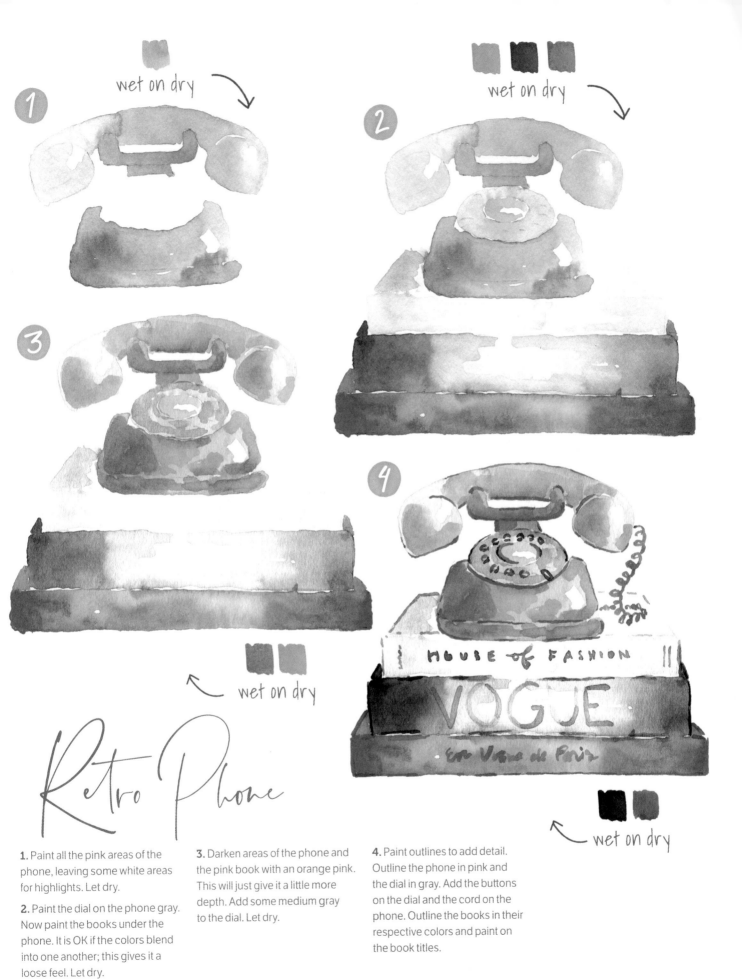

1 wet on dry

2 wet on dry

3

wet on dry

4

HOUSE of FASHION

VOGUE

Les Voix de Paris

wet on dry

Retro Phone

1. Paint all the pink areas of the phone, leaving some white areas for highlights. Let dry.

2. Paint the dial on the phone gray. Now paint the books under the phone. It is OK if the colors blend into one another; this gives it a loose feel. Let dry.

3. Darken areas of the phone and the pink book with an orange pink. This will just give it a little more depth. Add some medium gray to the dial. Let dry.

4. Paint outlines to add detail. Outline the phone in pink and the dial in gray. Add the buttons on the dial and the cord on the phone. Outline the books in their respective colors and paint on the book titles.

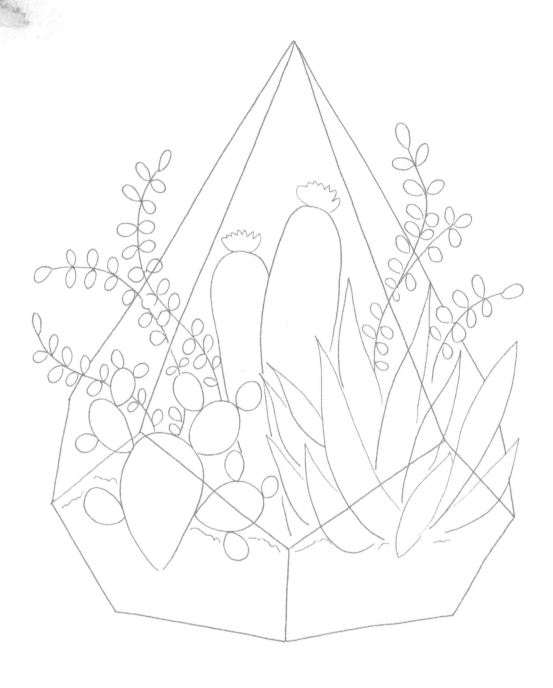

BRUSHES

• Medium brush for terrarium and cactus (4, 6)
• Small brush for smaller leaves and details (3)

COLOR PALETTE

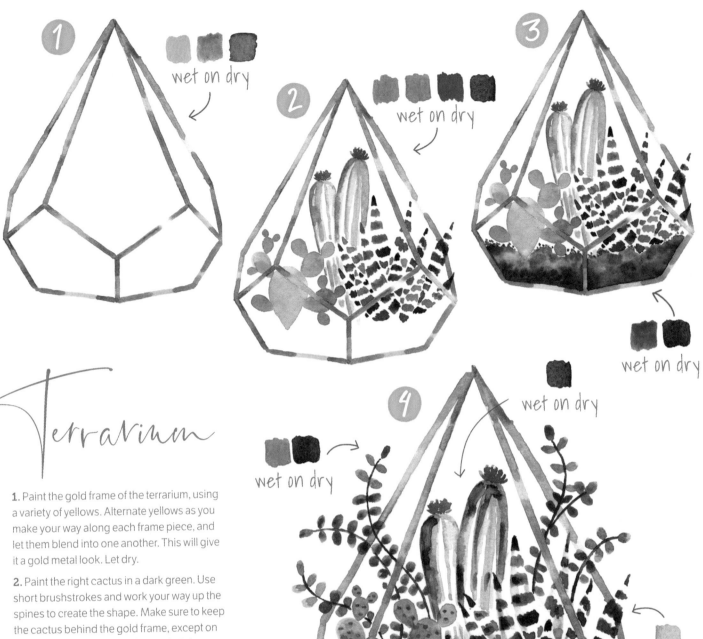

1 wet on dry

2 wet on dry

3 wet on dry

4 wet on dry

wet on dry

wet on dry

wet on dry

wet on dry

Terrarium

1. Paint the gold frame of the terrarium, using a variety of yellows. Alternate yellows as you make your way along each frame piece, and let them blend into one another. This will give it a gold metal look. Let dry.

2. Paint the right cactus in a dark green. Use short brushstrokes and work your way up the spines to create the shape. Make sure to keep the cactus behind the gold frame, except on the right side, where it peeks out. Let dry.

Paint the blue-green left cactus and make sure to keep it behind the gold frame. Let dry.

Paint the light-green middle cactus behind the previous two. Paint vertical lines to emphasize the shape. Add pink flowers to the cactus top. Let dry.

3. Paint the dirt inside the terrarium. Use a variety of watery browns to create different shades. Let dry.

4. Go in and darken and blend each cactus. For the left cactus, darken the sections on the left side to add depth, and blend with the rest of the cactus. Paint little dots for spines on top for texture. Let dry.

For the middle cactus, add some dark green to give it interest and define the shape. Let dry.

For the right cactus, take a very light green and paint over all the left sides of the spines. This should very subtly blend your green areas together and create a bit of shadow on the cactus. Let dry.

Add dark-brown dots to the dirt to create texture. Let dry.

Last, paint curved long sprigs of leaves to fill up the space. These should be behind the front pieces of the gold frame, but in front of the gold frame back pieces, like they are popping out the sides.

123

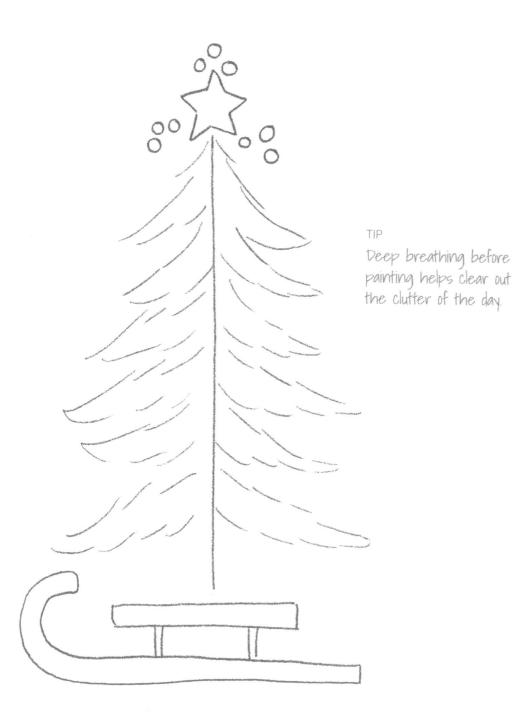

TIP
Deep breathing before painting helps clear out the clutter of the day.

BRUSHES
- Medium brush (4, 6)

COLOR PALETTE

Rustic Tree

1. Paint the trunk of the tree brown and paint a watery coat of green loosely coming out from the trunk. It is OK if the colors bleed into one another. Let dry.

2. Paint darker-green, short-feathered brushstrokes to give the impression of pine needles. Let dry.

3. Paint a yellow star with dots on the top of the tree. Paint a brown sled at the base of the tree.

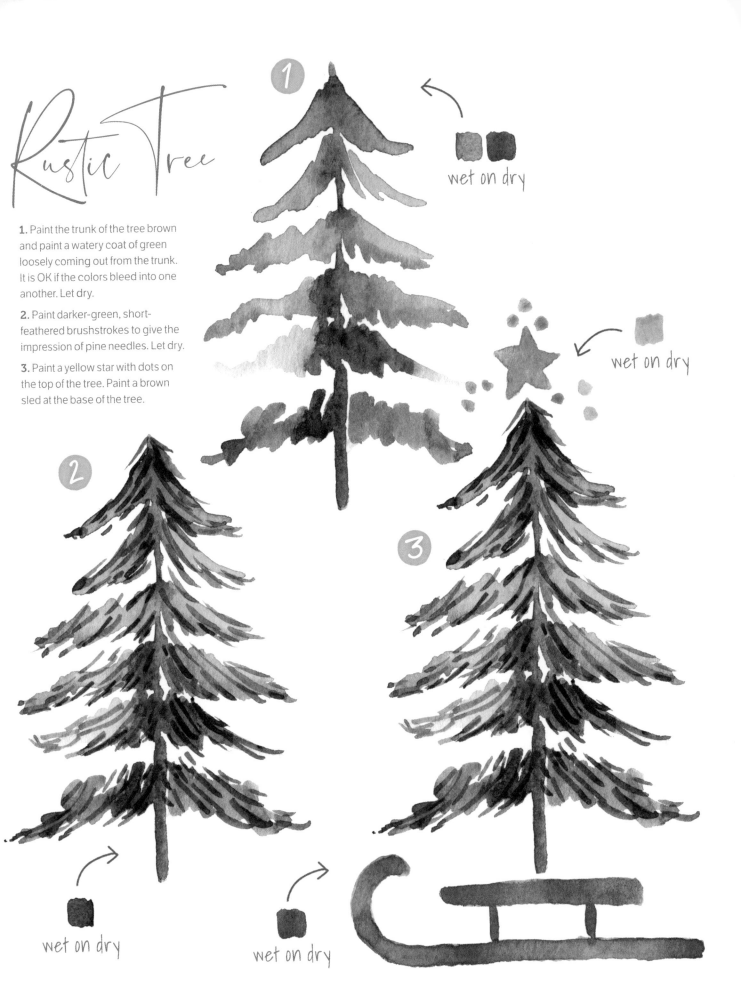

wet on dry

wet on dry

wet on dry

wet on dry

FUN TECHNIQUE—MASKING FLUID:
Masking fluid can be used to
preserve areas of the paper
you want to keep white.

BRUSHES

- Masking fluid
- Large brush (8, 10)

COLOR PALETTE

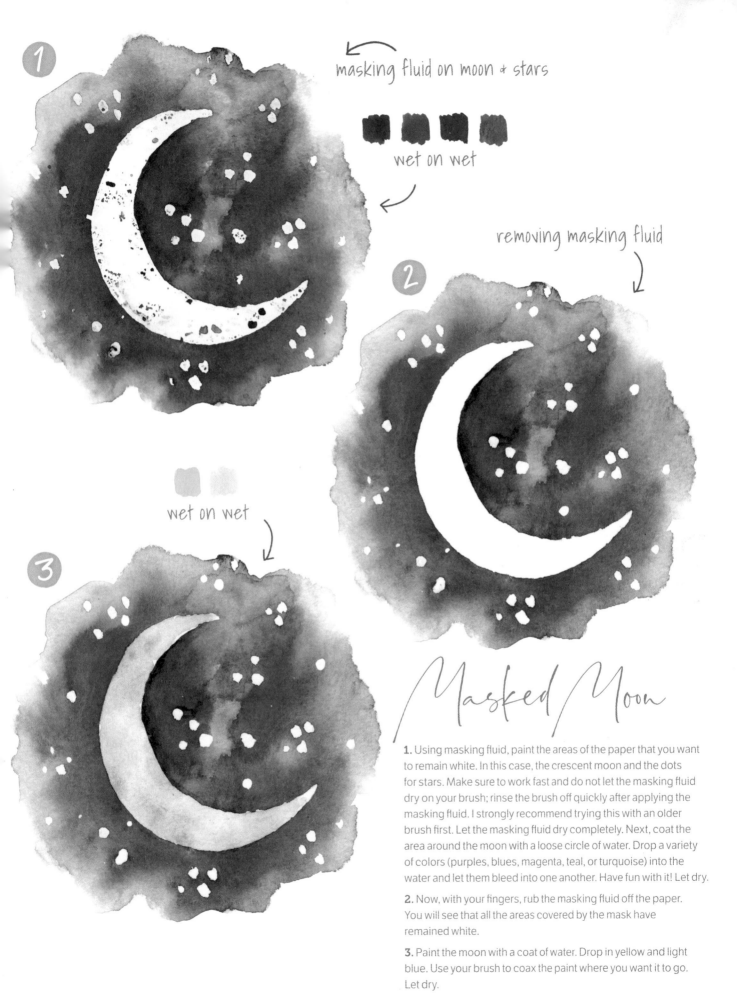

1

masking fluid on moon & stars

wet on wet

removing masking fluid

2

wet on wet

3

Masked Moon

1. Using masking fluid, paint the areas of the paper that you want to remain white. In this case, the crescent moon and the dots for stars. Make sure to work fast and do not let the masking fluid dry on your brush; rinse the brush off quickly after applying the masking fluid. I strongly recommend trying this with an older brush first. Let the masking fluid dry completely. Next, coat the area around the moon with a loose circle of water. Drop a variety of colors (purples, blues, magenta, teal, or turquoise) into the water and let them bleed into one another. Have fun with it! Let dry.

2. Now, with your fingers, rub the masking fluid off the paper. You will see that all the areas covered by the mask have remained white.

3. Paint the moon with a coat of water. Drop in yellow and light blue. Use your brush to coax the paint where you want it to go. Let dry.

Business is personal at Better Day Books. We were founded on the belief that all people are creative and that making things by hand is inherently good for us. It's important to us that you know how much we appreciate your support. The book you are holding in your hands was crafted with the artistic passion of the author and brought to life by a team of wildly enthusiastic creatives who believed it could inspire you. If it did, please drop us a line and let us know about it. Connect with us on Instagram, post a photo of your art, and let us know what other creative pursuits you are interested in learning about. It all matters to us. You're kind of a big deal.

it's a good day to have a better day!

BETTER DAY BOOKS
HAPPY · CREATIVE · CURATED

www.betterdaybooks.com

better_day_books